Innovation/Imagination

0 Years of Polaroid Photography

Innovation/

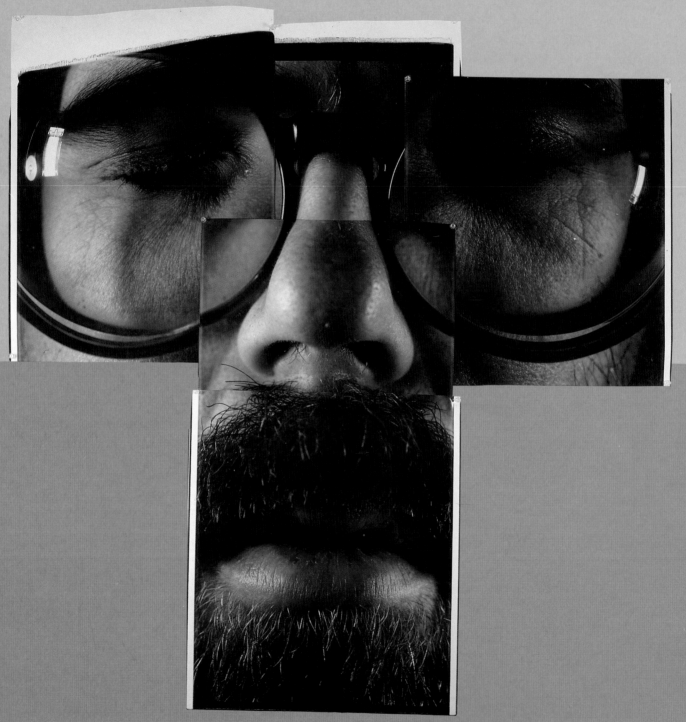

Imagination

Introductions by

Barbara Hitchcock

Deborah Klochko

Essay by

Deborah Martin Kao

50 Years of **Polaroid** Photography

Harry N. Abrams, Inc.,

Publishers *in*

association with

The Friends of

Photography

Project Manager: Eric Himmel
Editor: Nicole Columbus
Designer: Robert McKee

Library of Congress Cataloging-in-Publication Data
Innovation/Imagination : 50 years of Polaroid photography /
 introductions by Barbara Hitchcock, Deborah Klochko ;
 essay by Deborah Martin Kao.
 p. cm.
 Exhibition of selections from the Polaroid Collection held
 May 1999 at The Friends of Photography in San Francisco.
 Includes bibliographic references.
 ISBN 0–8109–4358–1
 1. Instant photography—Photograph collections—Exhibitions.
 2. Polaroid Corporation—Photograph collections—Exhibitions.
 I. The Friends of Photography.
TR269.I54 1999
779'.074744'6—dc21 98–42675

Harry N. Abrams, Inc.
100 Fifth Avenue
New York, N.Y. 10011
www.abramsbooks.com

Frontispiece: Chuck Close. USA. *Self-Portrait*. 1979. Polaroid 20x24 Polacolor photographs

Contents

Acknowledgments

A project of this scale is made possible by many individuals. The artists of *Innovation/Imagination* deserve the major credit for their vision and creative explorations, and Polaroid Corporation for supporting and preserving this rich legacy of work spanning a half century. Special thanks to Barbara Hitchcock, Director of Cultural Affairs at Polaroid, for her advice, ideas, and support for this exhibition and publication, and to her staff at the Polaroid Collection, Micaela Garzoni, Collection Coordinator, and interns, Benjamin Donaldson and Heather Cox.

In addition, The Friends of Photography's staff helped make this project a reality. Publications Manager Jun Ishimuro oversaw the production of this book, assisted by intern Kirsten Vincenz. Nora Kabat, Associate Curator, and Rose Fiorentino, Exhibitions Coordinator, put the exhibition tour together, and Julia Brashares, Director of Education, created a range of programs to accompany the exhibition. Finally, a special thanks to the rest of the staff, Sam Phillips, Heather Johnson, Elizabeth Casey, Magnolia Papac, Sharon Collins, and Liz Eurfre, for providing the support needed to make it all happen.

The Polaroid Collection

To some, he was an unconventional thinker. What others regarded impossible, he deemed a challenge. Perhaps that is why Edwin H. Land, inventor, scientist, educator, and founder of Polaroid Corporation, invented instant photography.

While vacationing in Santa Fe, New Mexico, Land photographed his young daughter, who wondered aloud why she couldn't see the picture he had just taken. What began with a child's innocent question resulted in a dramatic advance in photographic science and technology. Land quickly envisioned the idea of one-step photography; it then took him an hour to visualize the requirements for a camera, film, and chemistry system. This was 1944; by 1947 an instant sepia film was introduced to the world.

Scientific inquiry was Land's vocation, but he held art and literature in equal esteem. He said, "The purpose of inventing instant photography was essentially aesthetic—to make available a new medium of expression to numerous individuals who have an artistic interest in the world around them." Desiring an artist's perspective, in 1948 Land hired renowned landscape photographer Ansel Adams as a consultant to test and analyze cameras and films that scientists and engineers created in their labs. Artistic inquiry, he believed, would push products to their limits, exploring their parameters in a manner unlike the company's technical staff.

Ansel Adams was the first of many artists to scrutinize family, friends, flora and fauna with camera and instant film, gathering technical information to report to Polaroid. Following his lead, Minor White, Paul Caponigro, William Clift, and Nick Dean joined the team of expert practitioners during the 1950s and 1960s. Dean relates, "I had joined Polaroid in 1956 to work in Dr. Land's SX-70 laboratory. . . . My job interview was as unusual as the years that followed. Instead of the usual round of résumés and application forms, my audition was simply to spend a week photographing.

"When I returned with the prints, Dr. Land's assistant spread them out on a table, handed me a yellow pad, and asked me to make a list of everything I knew how to do, whether related to photography or not. Together, she and Dr. Land looked at the prints and at my list and announced that I was hired. Then from down the hall came Ansel Adams, an awesome figure to a young photographer. Waving an arm he said briskly, 'This is quite a place,' then disappeared."

A wealth of information was gathered through this enlightened—if unorthodox—process, helping to improve films and hardware, encouraging research to investigate uncharted territory. In addition, the company acquired the photographs the artists made. Meroe Marsten Morse, who managed Land's black-and-white laboratories, recognized that this work formed a technical and aesthetic document of the company's products and the beginning of a historic collection. By expanding the artist-corporation collaboration model, she established a program in which Polaroid products are bartered for exhibition-quality photographs. The Artist Support Program continues today, as artists from around the

world are selected through portfolio submissions. In addition, with the invention of each product, Polaroid has sought out artists to experiment with the new camera and film.

In the late 1960s the Polaroid Collection was officially founded. Acquiring photographs moved beyond the realm of research and development staff in the 1970s, when a formal collection committee was established, made up of volunteers from within the company; in the 1980s this volunteer committee was replaced by a careful selection of visually sophisticated employees and art professionals. The committee approach changed as company art professionals took responsibility for working with artists and museums, a practice that continues today.

As more and more emerging and established photographers worked with Polaroid cameras and films, the number of photographs selected for the company steadily increased. The early black-and-white work of Adams, Caponigro, Clift, Dean and others—influenced by the landscape tradition—is the foundation of the Polaroid Collection. The international component of the collection veered slightly from the established model by engaging acknowledged master photographers to work creatively with instant photography. Since then, the Collection has blossomed, gathering thoroughly modern experimental images as well as traditional images that echo an earlier era. Today the Collection consists of 23,000 photographs, located near corporate headquarters in Cambridge, Massachusetts, and in two museums in Paris and Lausanne.

Technological inquiry occurred on one hand while creative inquiry flourished on the other. Stimulated by each new Polaroid invention, talented artists sought fresh and unusual ways of expressing their visions on instant film. What would happen when black-and-white prints were left unfixed, exposed to air and light, then brushed with fixer-like paint on a canvas? Why not transfer the photographic dyes to watercolor paper, fabric, or even stone rather than to the intended photographic paper? The explorations of many fine artists testify to the unlimited creative possibilities of instant photography. The works reproduced here mark important advances made in Polaroid photographic science and symbolize five decades of artistic inventiveness.

When Edwin H. Land first envisioned a picture-taking process so easy that the photographer was freed from all but artistic considerations, he may not have envisioned the creative niche in photography's history attained by the instant medium. But then again, perhaps he did.

Barbara Hitchcock, Director of Cultural Affairs, Polaroid Collection, Polaroid Corporation

Introduction

The invention of photography was the result of science and art coming together to create a medium that would be embraced by both fields. Scientist and artist used the optics, chemistry, and creative genius available at the time to invent a means of capturing permanent images by the action of the sun.

In 1947 a radical new photographic technology was to change the field when Edwin H. Land, a scientist, introduced the first instant photographic process. Explaining the importance of his discovery, Land stated, "The process must be concealed from—nonexistent for—the photographer who, by definition, need think of the art in taking and not in making photographs. . . ." Ansel Adams met Land in 1948 and visited his laboratory, where Land took Adams's photograph with his prototype camera. "As it was peeled from its negative after just sixty seconds, the sepia-colored print had great clarity and luminosity. We were both beaming with the satisfaction of witnessing a photographic breakthrough come alive before our eyes. For Land it represented confirmation of a dream; for me it was a thrilling experience relating to the future of my craft and my first adventure with instant photography."[1]

Polaroid photography revolutionized the image-making process, producing a finished image that could be viewed in a matter of seconds, and it created a new genre of photography. A half century after Land invented instant photography,

1 Ansel Adams, *Ansel Adams: An Autobiography* (Boston: Little, Brown and Company, 1997), 247.

we are left with another legacy of his—an archive of over 20,000 images and several generations of artists who have had access to materials and the encouragement to create.

Today, 160 years after the introduction of photography and fifty years after the invention of instant photography, the beginning of a new century brings us to an important and defining moment in photographic history. Just as photography provided a new vision of how the world can be engaged, and instant photography created its own vocabulary of artistic innovation, new digital systems are now redefining the way we see and understand visual culture. As Ansel Adams said, "We must acquire and use the benefits of new technologies, and must explore new corridors of thought and feeling."[2]

Drawn entirely from the Polaroid Collection, *Innovation/Imagination* explores the creativity and experimentation of instant photography through a half century of work by artists as diverse as Ansel Adams, Andy Warhol, and Barbara Kasten. Examining both the evolution of process as well as artistic promise, the art included here provides a new chapter in the history of photography.

Deborah Klochko, Director, The Friends of Photography

2 Excerpt from a speech given by Ansel Adams at his 80th birthday celebration (1982).

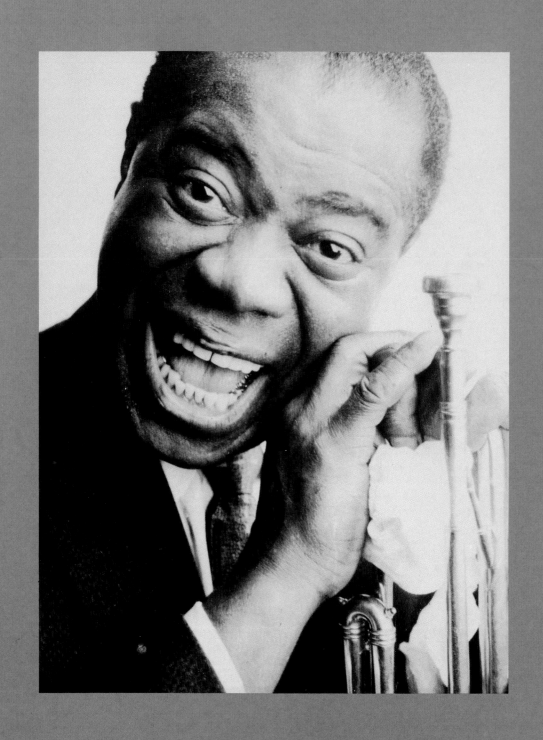

Bert Stern. USA. *Louis Armstrong.* 1958. Polaroid PolaPan 4x5 Land Film Type 52

Edwin Land's Polaroid: "A New Eye"

by Deborah Martin Kao

The magic of image making is that the spectacularly thin layers—almost merely layers of concepts—evoke in the observers of the image the whole spread of human emotions. It is hard to believe that such powerful responses are coming from such frail, delicate and inherently evanescent stimuli.[1]
—Edwin H. Land

[Land] is convinced that images can be as effective as words and that every person has a latent ability to make effective contact with another through visual statements.[2]
—Ansel Adams

Edwin H. Land, the founder of Polaroid Corporation, lauded photography as "a new eye, and a second memory" that "enhances the art of seeing."[3] For Land, who steadfastly held that scientific and aesthetic inquiry should extend the parameters of human knowledge, to see with "new eyes" became a personal credo, leading him to establish a maverick laboratory-based corporate structure at Polaroid—what he called a "noble prototype of industry"[4]—that advanced

I would like to extend my sincere gratitude to Robert Guenther, Vice President of Corporate Communications, Barbara Hitchcock, Director of Cultural Affairs, and Nasrin Rohani, Consulting Archivist, of Polaroid Corporation, for allowing me access to the Edwin H. Land and Ansel Adams correspondence and for facilitating my research at the Polaroid Corporation Archive.

1 Edwin H. Land, "Chairman's Letter," *Polaroid Corporation, Annual Report* (March 23, 1977): 5.
2 Ansel Adams, *Ansel Adams: An Autobiography* (Boston: Little, Brown and Company, 1985), 297.
3 Edwin H. Land, "Chairman's Letter," *Polaroid Corporation, Annual Report* (March 20, 1970): 4.
4 Edwin H. Land, "Chairman's Letter," *Polaroid Corporation, Annual Report* (March 23, 1979): 3.

innovation and rewarded imagination. Land believed that science and technology should "sense" and "fulfill" "deep human needs," and that such "research-centered operations" would per force lead to "highly desirable products."[5] In an address he delivered to the National Academy of Arts and Sciences in 1979, Land poetically iterated his long-held avowal that consequential intellectual discovery, such as that accomplished at Polaroid, redefines the ever-evolving boundaries of the human ken:

> Each stage of human civilization is defined by our mental structures: the concepts we create and then project upon the universe. They not only redescribe the universe but also in so doing modify it, both for our time and for subsequent generations. This process—the revision of old cortical structures and the formulation of new cortical structures whereby the universe is defined—is carried on in science and art by the most creative and talented minds in each generation.[6]

Embedded within Land's visionary manifesto lies a reference to the fundamental and enduring paradox of photography's place in modern culture: photography is viewed as both a mechanical tool capable of accurately transposing the natural world for scientific inquiry and social scrutiny, and as a pliable process of subjective visual expression bound only by the syntax of its technology.

The debate between those who delineate photography as a transparent medium versus those who interpret it as a mediated fiction has been passionately argued from the very inception of its invention. Early photography was considered a scientific wonder and a technological achievement, yet only a "handmaiden" of the arts. The unique mimetic qualities of the medium led early critics of photography to question its independent creative potential. Such sentiments are typified by the comments of William Henry Fox Talbot, the inventor of the calotype, one of the first photographic processes. Invoking photography as a metaphor for the conquest of mortality by reason—of time rendered still by science—he marveled:

> The most transitory of things, a shadow, the proverbial emblem of all that is fleeting and momentary, may be fettered by the spells of our "natural magic," and may be fixed for ever in the position which it seemed only destined for a single instant to occupy. This remarkable phenomenon, of what ever value it may turn out in its application to the arts, will at least be accepted as new proof of the value of the inductive methods of modern science.[7]

5 "Interview of Edwin H. Land by Robert W. Lougee of *Business Week*" (January 9, 1981), transcript of tape in Polaroid Corporation Archive: 10–11.

6 Quoted in Adams, *Ansel Adams: An Autobiography*, 306.

7 William Henry Fox Talbot, "Some Accounts of the Art of Photogenic Drawing," *The London and Edinburgh Philosophical Magazine and Journal of Science*, vol. XIV (March 1839), reprinted in Vicki Goldberg, *Photography in Print* (Albuquerque: University of New Mexico Press, 1981), 40–41.

Bound to the viewers' expectation of the luminescent scenes framed and rendered automatically in perspective by the camera obscura, early photographic technologies were continually modified to fulfill a specific idea about how nineteenth-century Western society wanted the world to look when constructed on a flat picture plane—a point evinced in the many "failures" of early photography to meet the demands of similitude expected by its viewing public. In response to the often contentious critical barriers erected against the acceptance of photography as an art form, beyond the use of photography for memory studies and reproductive prints, nearly the first century of "artistic" photographers subverted the scientific and mechanical aspects of the medium, imitating and appropriating the conventional subjects and styles displayed in the salons of Europe as a way to illustrate photography's potential as a medium for creative expression.

Surveying the scientific and aesthetic terrain forged by early practitioners of photography, Land noticed that scientific advances in photography remained oddly absent from overt reference in artistic practice, even as the development of new photographic techniques significantly modified the landscape of visual culture on every front. "In the past," Land wrote, "photography with its easy synthesis of structured perspective was automatically cast in the role of the ultimate delineative art, and came to be rejected as an esthetic medium." However, he continued, "as I become more sophisticated about cognition and perception, I realize that photography . . . can only *appear* to delineate."[8] It was exactly this understanding of photography's capacity for aesthetic relativism within its technological syntax that inspired Land to work with artists during the research and development phase of Polaroid products.

Land's initial experiments in the science of light and optics in the late 1920s and 1930s came at a moment when attitudes about both the "delineative" and "aesthetic" meaning of photography within the larger culture were greatly shifting. The early twentieth-century avant-garde celebrated all manner of photographic imaging as the universal language of the revolutionary modern age, and a self-consciously mechanistic and scientific aesthetic emerged in art photography, called the "New Vision." Associated with the larger embrace of the machine age, the new photography with its camera-eye point of view became the very measure of modern culture. As László Moholy-Nagy, one of the New Vision's principal proponents and theorists contended, "Scientific and technological advances almost amount to a psychological transformation of our vision," because "photography imparts a heightened and increased power of sight."[9]

The new photography movements of the early twentieth century also gave rise to diverse photographic practices, and artists and their audiences found increasing aesthetic and cultural meaning in scientific photography, including microscopic, telescopic, aerial, and x-ray. Many artists began to appropriate and integrate scientific and documentary photographs into their art. The science that gave form to the art of photography and the application of photography in the sciences had now become the epicenter of aesthetic discourse on the medium. The extent of Polaroid's experimentation with diverse photographic applications—from improved films for x-ray and stereoscopic vision to classified surveil-

8 Edwin H. Land, "Private Ruminations on Looking at Ansel Adams' Photographs," in *Ansel Adams: Singular Images* (Dobbs Ferry, N.Y.: Morgan and Morgan, c. 1947), unpaginated. (Italics added.)
9 László Moholy-Nagy, *Vision in Motion* (Chicago: Paul Theobald, 1947), 206–7.

lance photographic technologies for military use to the mass appeal of the instant snapshot—can be framed by the larger and nearly ubiquitous cultural impetus toward integrated practice in science and design. Parallels exist, for example, between the Bauhaus-inspired laboratory schools and curricula that were established in the United States in the 1930s and 1940s at institutions such as the WPA-funded Laboratory School of Industrial Design in New York, the New Bauhaus (later renamed the Institute of Design) in Chicago, and design programs at both the Massachusetts Institute of Technology and Harvard University in Cambridge, in which photography remained a linchpin of the design discovery process, and the environment that Land built during the early years of Polaroid. Promoting Polaroid Corporation as a prototype for such an innovation-based industry, Land boasted that the "combination of concentration of purpose and diversification of technique has led to the evolution of an organization with a special ability to be daringly creative on a continuous basis, not only in research, where one would expect it, but also in engineering, development and manufacturing."[10]

Land maintained that "industry at its best is the intersection of science and art,"[11] and consequently the Polaroid Corporation integrated research into the aesthetic dimension of photography and provided support for artists' experimentation with Polaroid materials. From the outset, Land promoted collaboration with artist-consultants such as Ansel Adams, Paul Caponigro, William Clift, Nicholas Dean, Minor White, and Marie Cosindas in all aspects of the corporation, including research, development and testing, instructional publications, and marketing. A system encouraging artists to probe the physical and conceptual boundaries of Polaroid materials through the loan and donation of products and through direct grants was established. The company further built an impressive collection of art photographs, published a newsletter for photographic educators and a journal dedicated to Polaroid art, and established a corporate gallery named after Land's lifelong colleague, the photographer and art historian Clarence Kennedy.

For Land, Kennedy's and Adams's explorations using Polaroid photography were not only an essential component of the innovative process, but they acted as paradigm and inspiration. "In the 1935–45 period," Land said, "the beauty of the pictures by Kennedy and Adams played a striking inspirational role not so much in leading us to make beautiful pictures . . . as to drive us toward 'beautiful' science as the basis for ultimate beauty in pictures."[12] Land's association with Kennedy began in the 1930s, when they worked together to develop a system for projecting stereoscopic lantern slides of Renaissance sculpture by using Polaroid filters over a double lens. Frustrated by the prosaic reproductions of great works of sculpture offered by commercial venders, Kennedy sought out subtle lighting strategies and other technologies to find a photographic documentation of sculpture that evoked the essence of the piece. Kennedy's photographs were widely praised; Beaumont Newhall called them "explanation, criticism, interpretation" and further suggested that "they open our eyes to a fresh understanding and appreciation."[13]

10 Edwin H. Land, "Chairman's Letter," *Polaroid Corporation, Annual Report* (March 20, 1970): 4.

11 Edwin H. Land, quoted in *The Intersection of Industry and Art 1937–1987* (Cambridge, Mass.: Polaroid Corporation, 1987), frontispiece.

12 Edwin H. Land, "Chairman's Letter," *Polaroid Corporation, Annual Report* (March 23, 1979): 5.

13 Beaumont Newhall, "Clarence Kennedy," in *Photographs by Clarence Kennedy* (Northampton, Mass.: Smith College Museum of Art, 1967), 12.

Ansel Adams acted as a special consultant to Polaroid Corporation beginning with the invention of the first Polaroid Land camera in 1948. In an early letter to Adams, Land wrote, "My own admiration for your combination of aesthetic and technical competence is complete."[14] In an advertising insert to the 1955 issue of the *US Camera Annual*, Adams contributed an important testimony for Polaroid photography, placing it within the larger context of the great technical and aesthetic developments in the history of the medium:

> Photography is the most virile medium of communication and expression of our time. From the first miracles of Daguerre, Talbot and Hill, through the periods of the "wet" plate, the "dry" plate, the sheet film and color photography, to the impressive developments of today, the camera had maintained a spectacular growth and an ever increasing significance. . . . [F]rom the very start I sensed the great potential of this new [Polaroid] process in all fields of work.[15]

In his capacity as a consultant to Polaroid, Adams tested new inventions, giving input on the quality and performance of photographic technologies—both cameras and films—under development. Hundreds of lengthy technical memoranda between Adams, Land, and Meroe Marsten Morse, the research manager of black-and-white photography at Polaroid and the frequent contact between scientists and artists at the corporation, survive as testament to Adams's share in the research process. In addition to technical feedback, Adams regularly gave commentary on the philosophical and aesthetic directions in which he saw the company moving over the years. He suggested avenues through which Polaroid could support artistic photography, such as educational programs, publications, and exhibitions, and at times he reminded the company of its ideals when he believed that bureaucracy and the market were threatening issues of innovation and transcendence. Adams also encouraged Polaroid scientists to respect the concerns of "creative photographers," as evinced in a memorandum from Adams to Land in January of 1954:

> It is safe to assume that "creative" photography . . . involves many subtle controls. . . . [T]he expressive print *demands* a wide variety of controls. Hence the fallacy at this time to assume that the Land process should compete with the established forms of print-controlled "creative" photography. Rather, it should be thought of as a new and different form in which the elements of selection and careful composition would dominate. . . . [I]t can be only a matter of a short time before the process is greatly extended in the expressive fields.[16]

For most people Polaroid remains synonymous with "instant photography." Land, who frequently recounted what he called the "true apocryphal story" that his young daughter's impatience to see a photograph inspired the idea of instant

14 Edwin H. Land letter to Ansel Adams (February 1, 1949), reprinted in Adams, *Ansel Adams: An Autobiography*, 295.

15 Ansel Adams, "Ten Photographs by Ansel Adams," *US Camera Annual*, 1955, advertising insert for Polaroid photography: unpaginated.

16 Memorandum from Ansel Adams to Edwin Land (January 1, 1954), Polaroid Corporation Archive.

photography, also often remarked that the invention only appeared inevitable in retrospect because of its tremendous cultural resonance.[17] Polaroid's indelible association with instant vision eventually frustrated Land, who in 1979 wrote, "To allow the term instant photography to subsume our contribution to photography since 1944 is like saying that an airplane is an automobile that flies."[18] Nevertheless, for him, instant photography fulfilled both a social and an aesthetic function. In an early paper he delivered titled "One-Step Photography," Land stated his belief that instant photography would eliminate the baffles between photographer and subject:

> In the earlier arts the artist initiates his activity by observing his subject matter and then responds. . . . [W]ith photography, except for those who combine long training, high technical ability, and splendid imagination, this important kind of double stimulus—original subject and partly finished work—can not exist. . . . This new [one-step] photographic program seeks to contribute to satisfying this aesthetic need. By making it possible for the photographer to observe his work and his subject matter simultaneously, and by removing most of the manipulative barriers between photographer and the photograph.[19]

The apotheosis of Polaroid instant photography occurred in 1972 with the release of the Polaroid Land SX-70 Camera, which Ansel Adams called "a true milestone in the development of photography as an art."[20] Max Kozloff has aptly characterized the SX-70's remarkable wedding of science and aesthetics, writing that "the SX-70 fuses photographic objectives and advanced technology with transformed rendering. It encourages the most nakedly candid revelations, which are both vernacular and unassuming, but tends also to produce quite mysteriously evocative images. It performs a complex sequence of operations, repeatedly, and yet it sustains itself as an experimental form."[21] The SX-70 came of age during a period of intense scrutiny of mass consumerism and obsession with popular culture. The snapshot aesthetic to which the SX-70 helped give rise became fodder for artists such as Andy Warhol and Robert Heinecken, who approached it as a cultural "ready-made." Other artists, such as Lucas Samaras, substantially manipulated the photographic process, during exposure—by the use of projected colored light—and during development—by pressing and scratching the prints. This served to accentuate the distance between the perception of reality as captured in the "amateur snapshot" process and the artist's construction of a new reality within that matrix.

17 John Sanders, "Questions to Dr. Land," *The Photographic Journal*, Official Journal of the Royal Photographic Society, vol. 113, no. 5 (May 1973): 215.

18 Edwin H. Land, "Chairman's Letter," *Polaroid Corporation, Annual Report* (March 23, 1977): 7.

19 Edwin H. Land, "One-Step Photography," *The Photographic Journal*, Official Journal of the Royal Photographic Society of Great Britain and the Photographic Alliance, vol. 90A (January 1950): 7.

20 Memorandum from Ansel Adams to Polaroid Corporation (February 27, 1973), Polaroid Corporation Archive.

21 Max Kozloff, "Introduction," *SX-70 Art* (New York: Lustrum Press, Inc., 1979), 11.

The 20x24 camera, which produces 20x24" photographs, was first used by artists in 1978. It shares the technology of instant photography with the small handheld camera with which Polaroid is popularly associated, but the optical properties of the camera and its physical scale make it a markedly different process. Cumbersome to handle, the 20x24 remains a technology most frequently used in the studio, with the help of Polaroid technicians. In many ways the 20x24 camera brings us full circle to an aesthetic reminiscent of the large-format cameras of photography's early history, leading photographer Gary Metz to write: "In the context of their tremendous size, their irridescent color, their formidable optics, their promiscuous topographic completeness—the 20x24 pictures recover the first moments of photography's public history. It is as if we have the opportunity to start all over again."[22] Yet for all the ways in which it conjures the past, the 20x24 remains a thoroughly late twentieth-century technology—with its titanium processing rollers, digital electronics, carbon-filament parts, and Polacolor film.

The development of Polaroid Corporation's photographic-imaging technologies has informed and at times propelled the larger history of the photographic medium—aesthetic and applied—over the past fifty years. As A. D. Coleman stated, "Polaroid's influence on the work created by those who use Polaroid systems to generate 'art photography' is hardly limited to the consequences of the structure of the materials alone. Rather, it extends much further—it is now intertwined with the economics, production context, presentation and dissemination of the imagery itself."[23] Perhaps the most meaningful tribute to Polaroid's remarkable contribution to our shared visual culture is made by those artists who, like Land, seek revolutions in visual expression. Land's caveat to young innovators in 1981 continues to stand well as an anthem for contemporary artists: "The only thing that I have learned in the course of a lifetime is that the reactionary attitudes, which you take for granted at the beginning of the inception of a dangerous and exciting undertaking, never really die down."[24]

22 Gary Metz, "Through the Rear View Mirror: Daguerre's Dream Larger Than Life," *20x24/Light* (New York: Light Gallery, The Philadelphia College of Art, and Polaroid Corporation, 1980).

23 A. D. Coleman, "Polaroid: Toward a Dangerous Future," *Photoshow* 3 (1980): unpaginated.

24 "Interview of Edwin H. Land by Robert W. Lougee of *Business Week*": 22.

Photographs

The 1950s

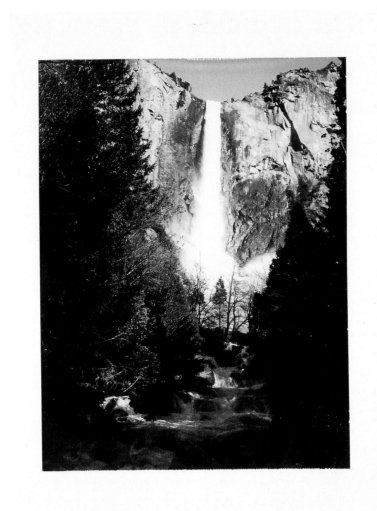

Ansel Adams. USA. *Cascades*. 1956. Polaroid PolaPan Land Film Type 53

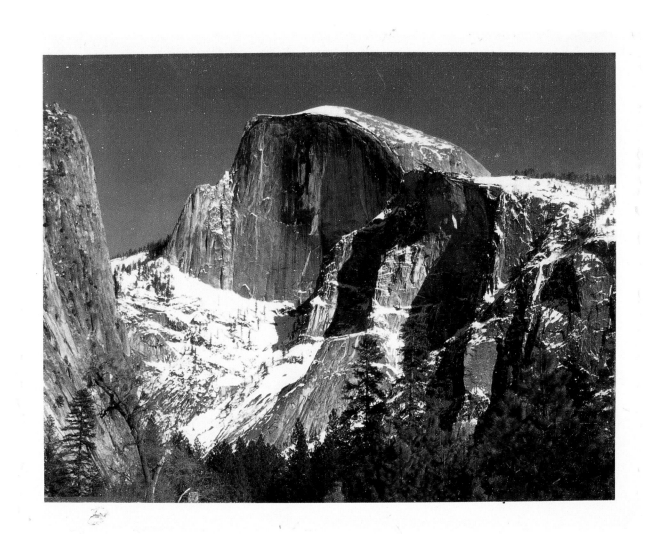

Ansel Adams. USA. *Yosemite*. 1955. Polaroid PolaPan 200 Land Film Type 42

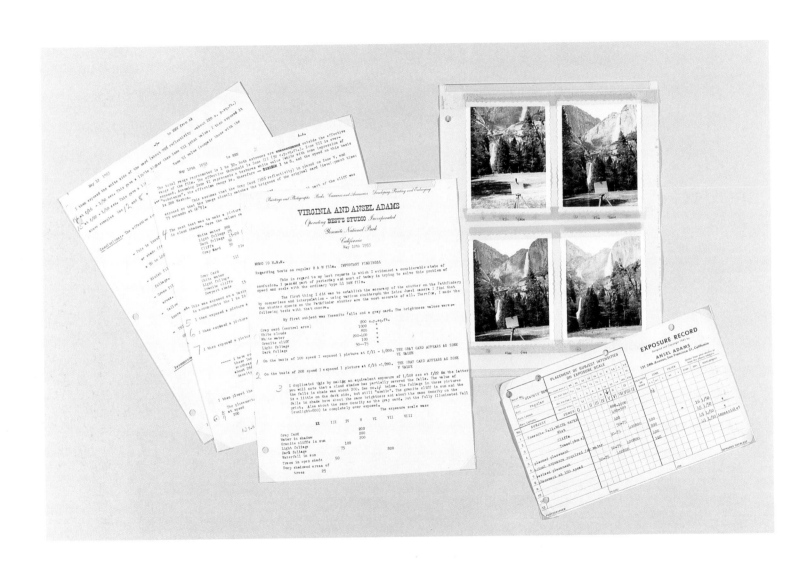

Ansel Adams. USA. *Memorandum to Meroe Morse, Research Manager of Black & White Photography.*
1953. Text and Polaroid Land Film Type 41 photographs

24

Photographs

The 1960s

Philippe Halsman. USA. *Mrs. Gianni Agnelli.* 1963. Polaroid PolaPan 200 Land Film Type 42

Philippe Halsman. USA. *Salvador Dalí*. 1969. Polaroid PolaPan 4x5 Land Film Type 52

Brett Weston. USA. *Untitled.* 1966. Polaroid High-speed Land Film Type 57

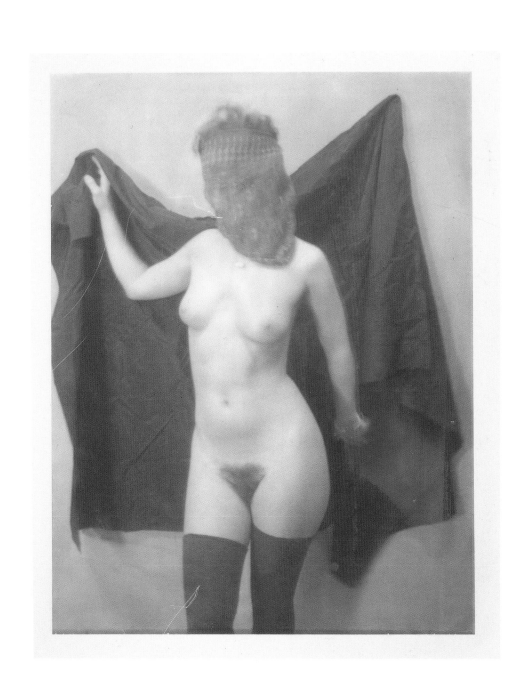

Weston Andrews. USA. *Untitled*. 1966. Toned Polaroid Positive/Negative 4x5 Land Film Type 55

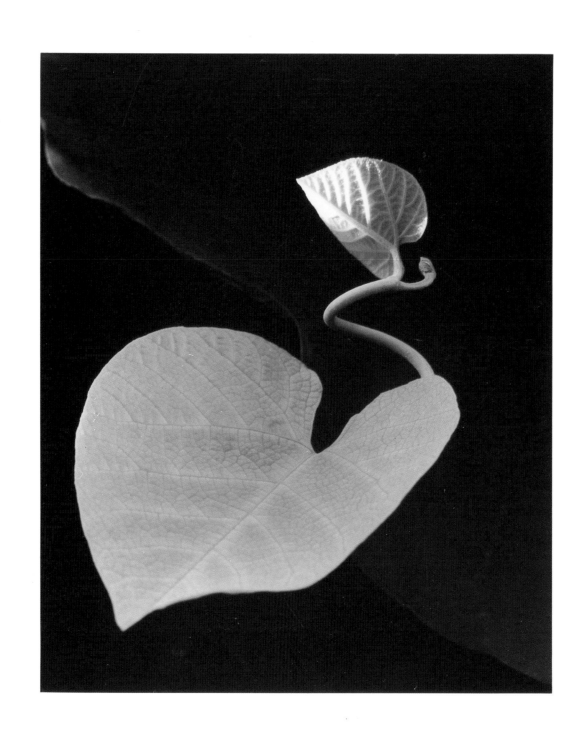

Paul Caponigro. USA. *Two Leaves, Brewster, New York.* 1963.
Gelatin silver print from Polaroid Positive/Negative 4x5 Land Film Type 55

Photographs

The 1970s

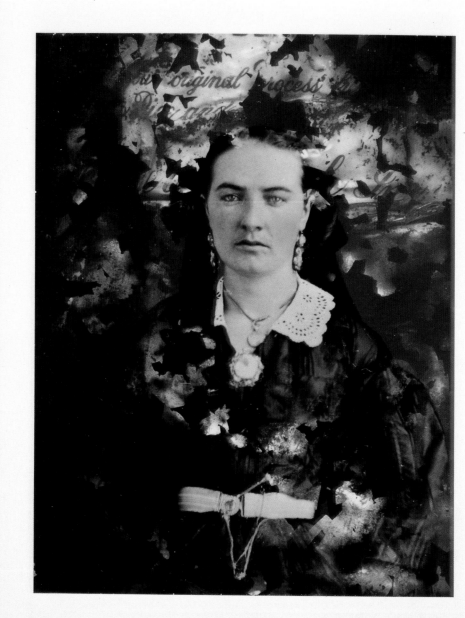

Rosamond Wolff Purcell. USA. *Original.* 1978. Polaroid Polacolor 4x5 film Type 58

Rosamond Wolff Purcell. USA. *Signs of Life*. 1974. Polaroid Positive/Negative film Type 105

Ralph Gibson. USA. *Nude Profile.* 1979. Polaroid 20x24 Polacolor photograph

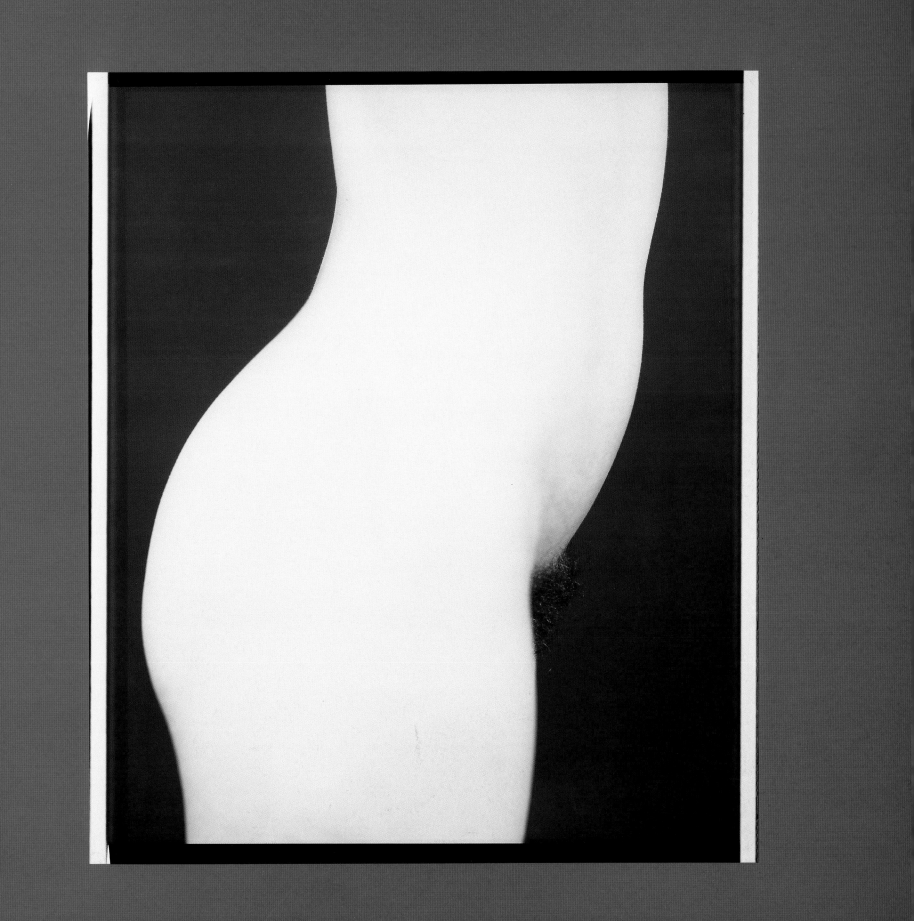

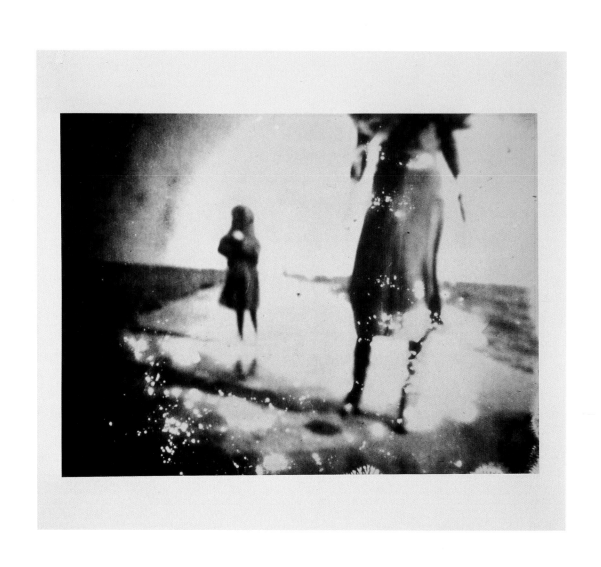

Deborah Turbeville. USA. *American Vogue Shoe Editorial.* 1975.
Gelatin silver print from Polaroid Positive/Negative film Type 665

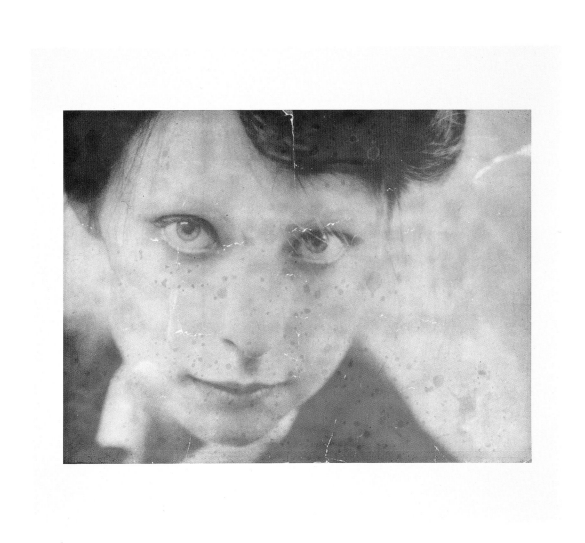

Deborah Turbeville. USA. *Forgotten Girl.* 1973. Toned gelatin silver print from Polaroid Positive/Negative film Type 665

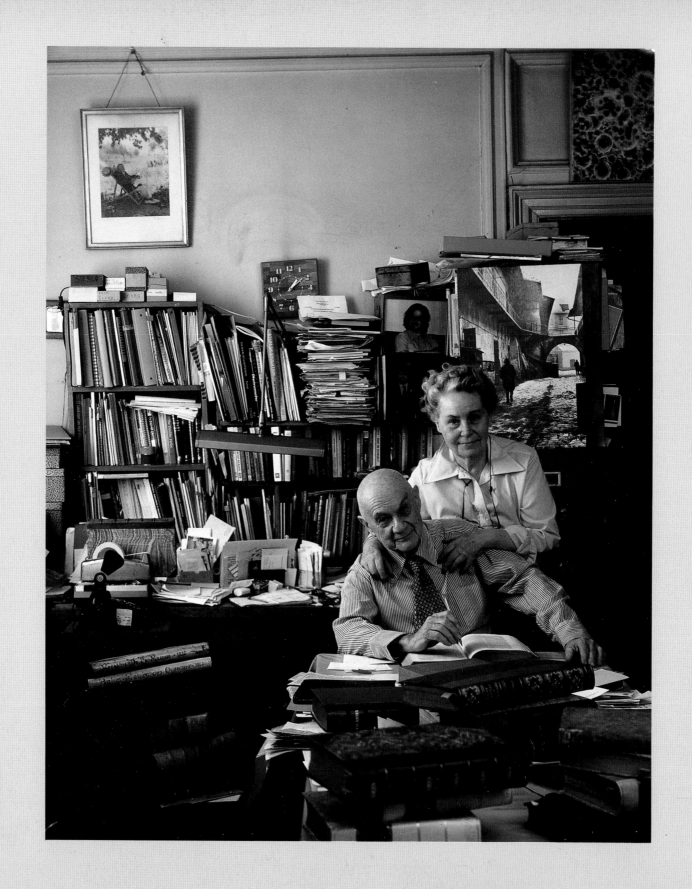

Arnold Newman. USA. *Roman Vishniac and His Wife Edith.* 1978. Polaroid Polacolor 8x10 film Type 808

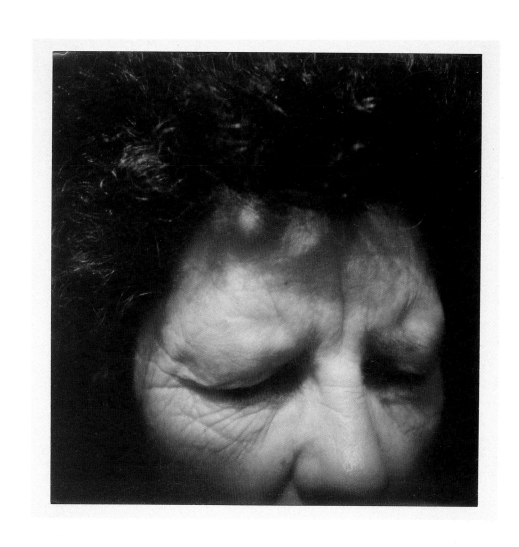

Eugene Richards. USA. *My Mother Helen.* 1974. Polaroid SX-70 photograph

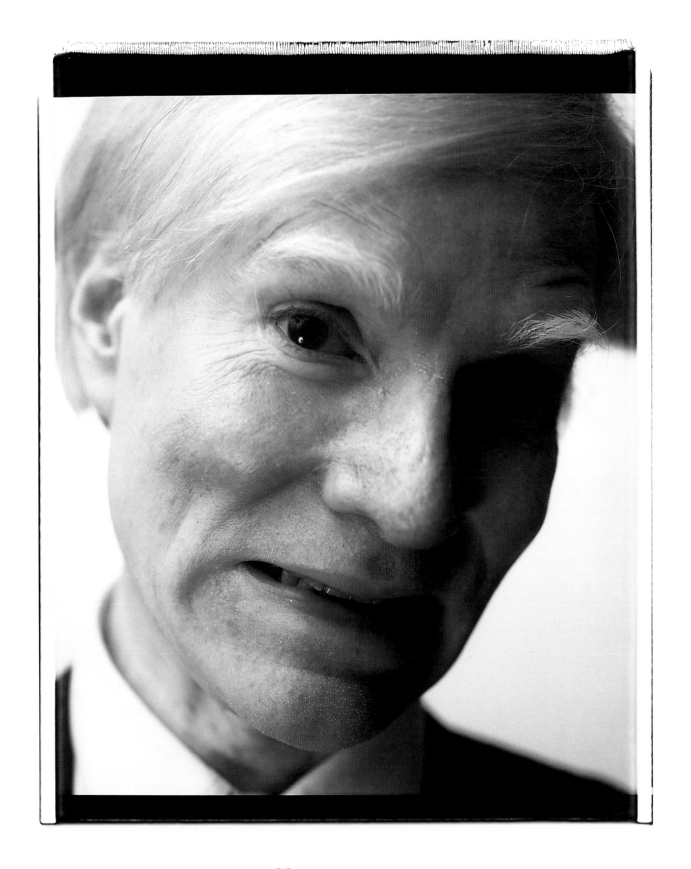

Andy Warhol. USA. *Untitled*. 1979. Polaroid 20x24 Polacolor photograph

Minor White. USA. *Untitled.* 1975. Polaroid PolaPan 4x5 Land Film Type 52

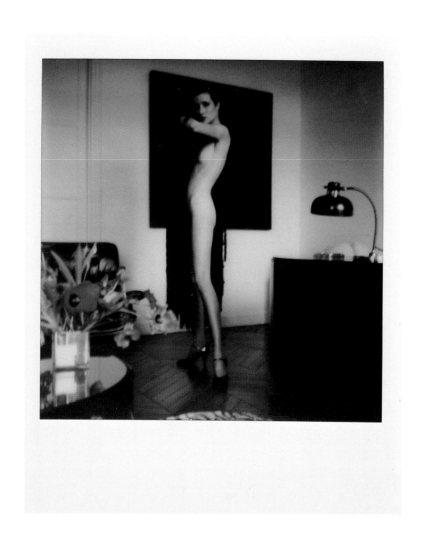

Helmut Newton. Australia. *Untitled.* 1976. Polaroid SX-70 photograph

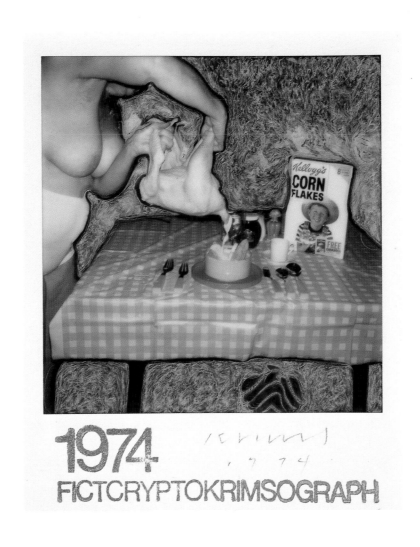

Les Krims. USA. *Chicken Pisher Pitcher Picture.* 1974. Manipulated Polaroid SX-70 photograph

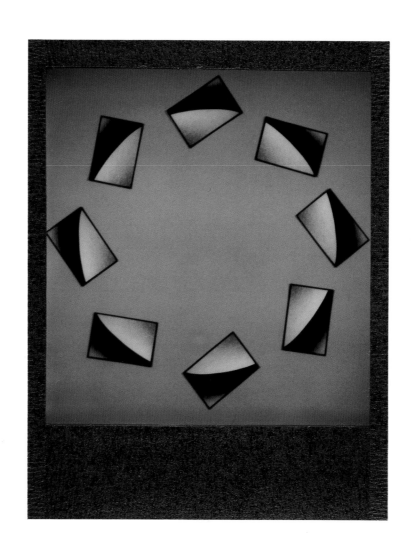

Robb Buitenman. Holland. *Untitled*. 1979. Polaroid SX-70 photograph

Photographs

The 1980s

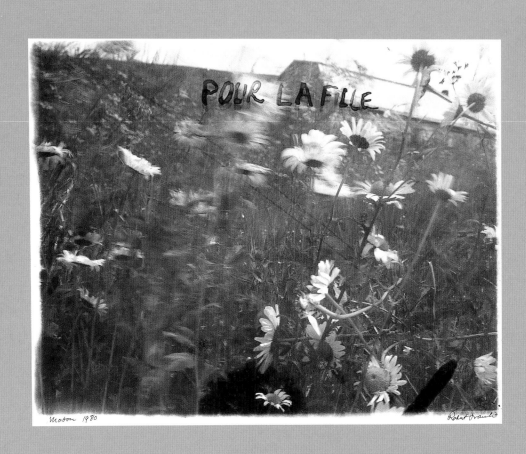

Robert Frank. USA. *Pour la fille, Mabou.* 1980.
Gelatin silver print from Polaroid Positive/Negative film Type 665

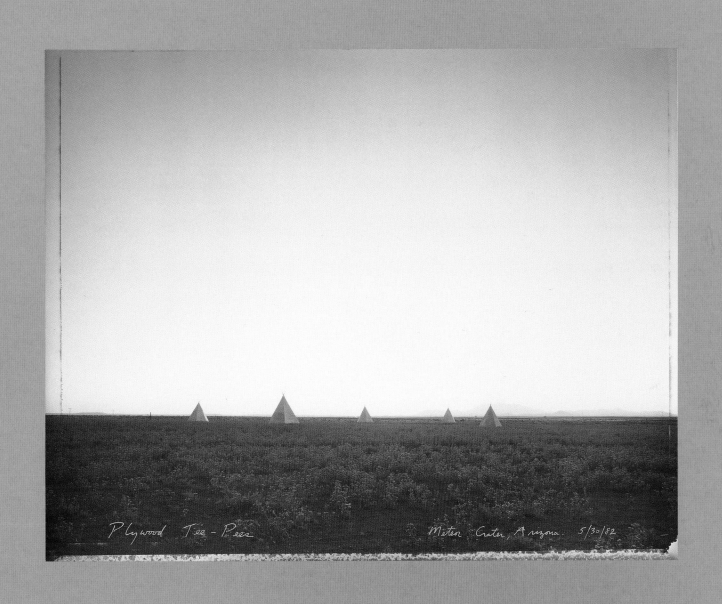

Plywood Tee-Pees

Meteor Crater, Arizona 5/30/82

Mark Klett. USA. *Plywood Tee-pees, Meteor Crater, Arizona. 1982.*
Gelatin silver print from Polaroid Positive/Negative 4x5 film Type 55

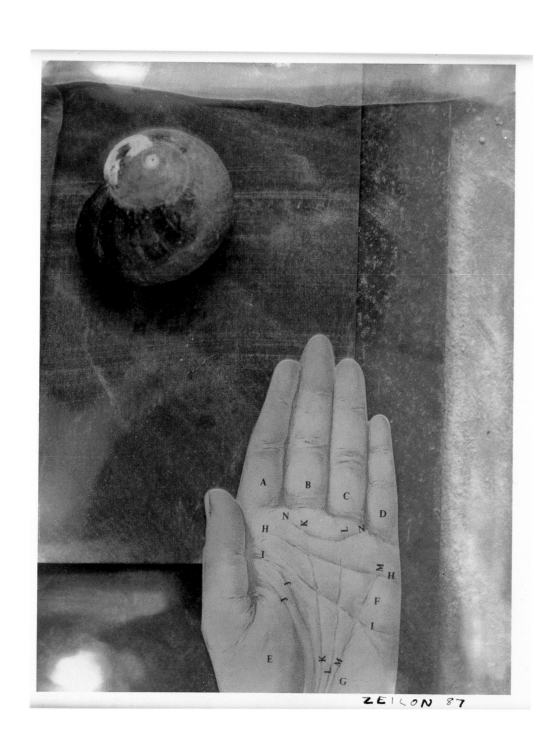

Elisabeth Zeilon. Switzerland. *Promise.* 1987.
Color coupler print from Polaroid Professional Chrome 4x5 film

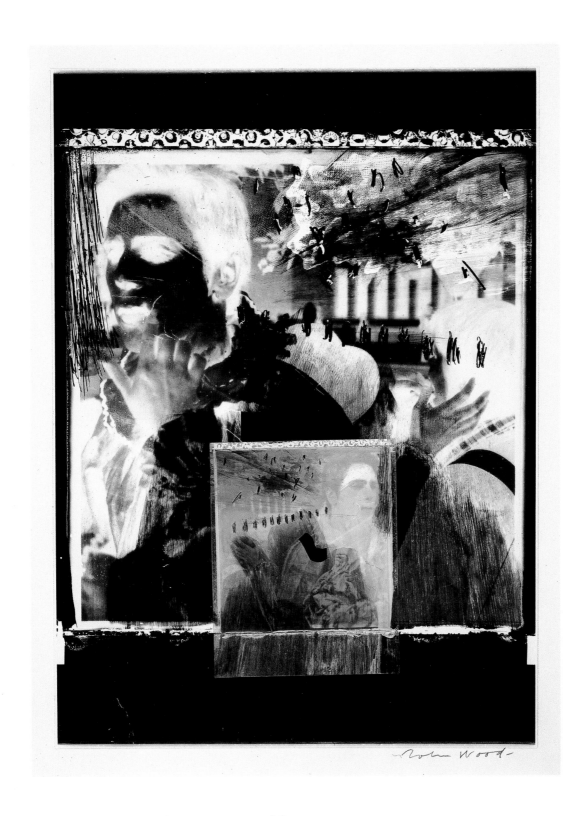

John Wood. USA. *Using Dave Heath's Rejects as Negatives*. 1984.
Gelatin silver print and Polaroid Time-Zero collage

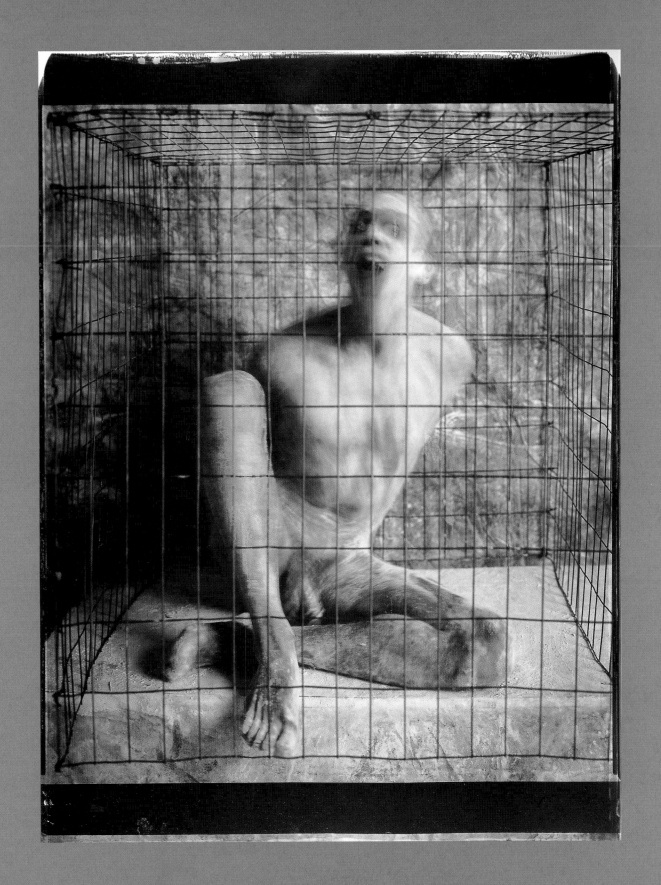

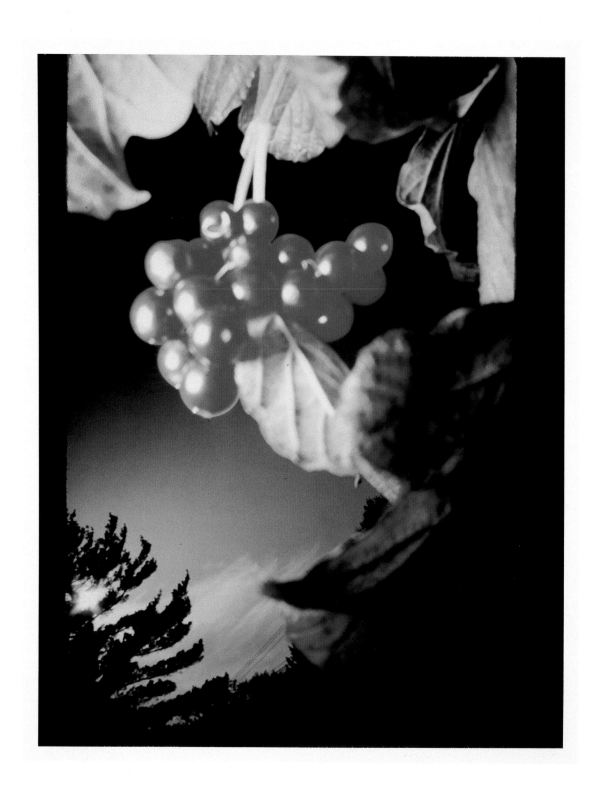

Barbara Crane. USA. *Visions of Enarc.* 1983—86. Polaroid Polacolor 8x10 film Type 808

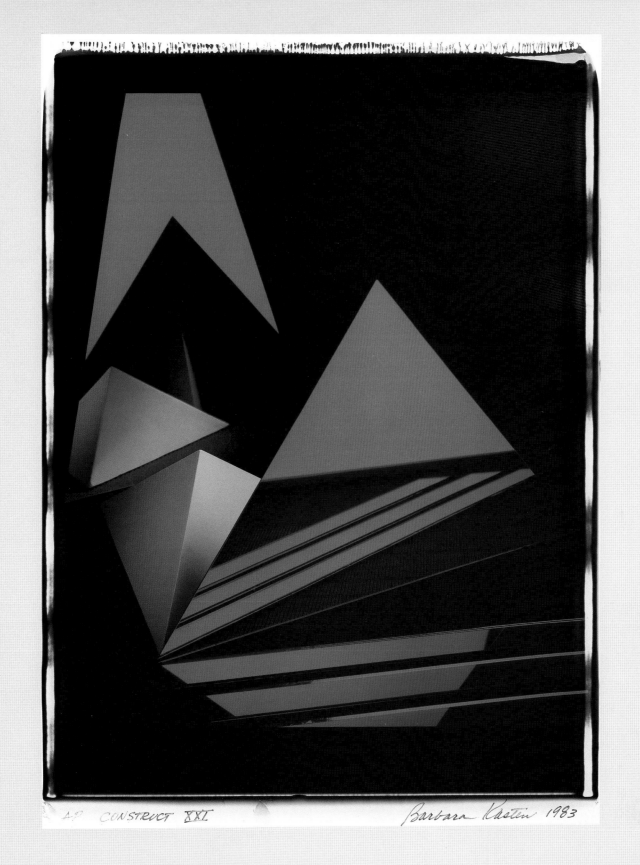

AP CONSTRUCT XXI Barbara Kasten 1983

Barbara Kasten. USA. *Construct XXI.* 1983. Polaroid 20x24 Polacolor photograph

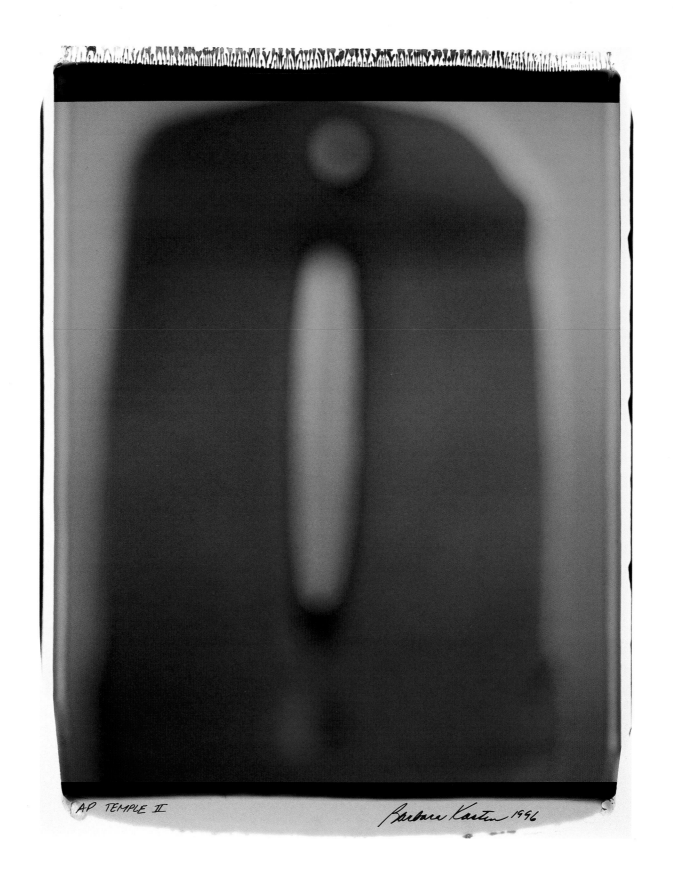

AP TEMPLE II

Barbara Kasten 1996

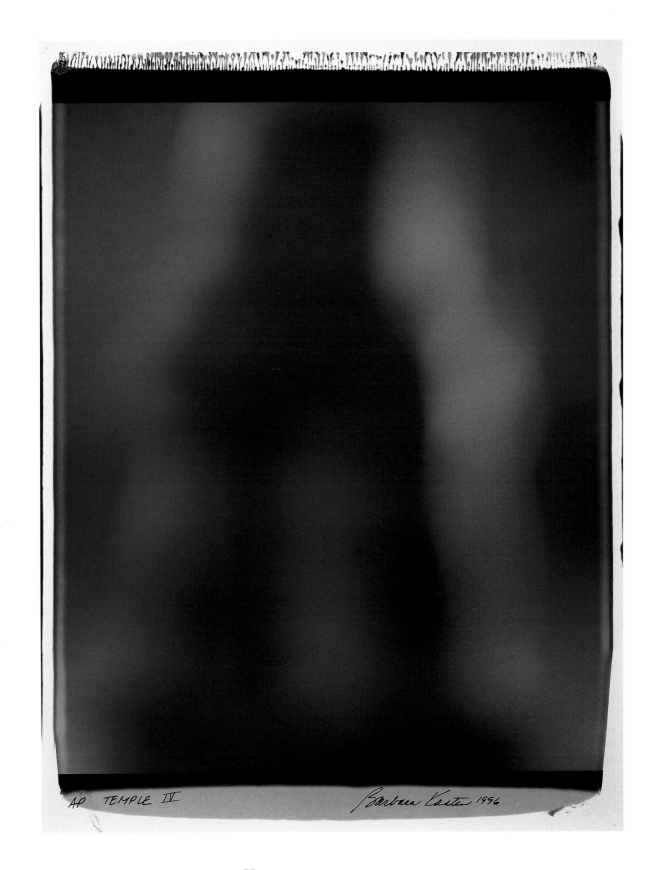

AP TEMPLE IV *Barbara Kasten 1996*

Barbara Kasten. USA. *Temple IV*. 1996. Polaroid 20x24 Polacolor photograph

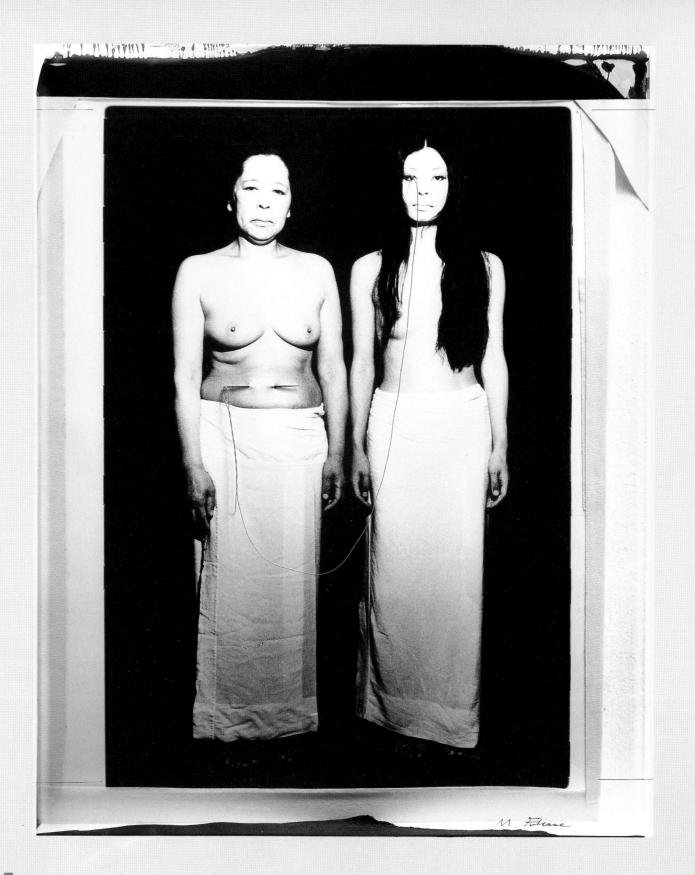

Masahisa Fukase. Japan. *The Game*. 1983. Polaroid 20x24 Polacolor photograph

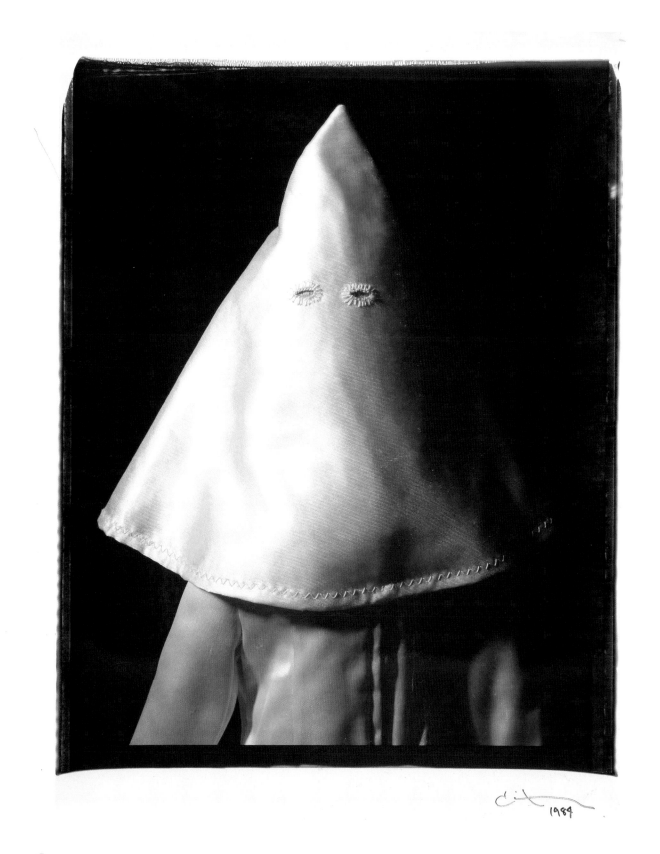

59 William Christenberry. USA. *KKK* from *The Klan Tableau*. 1984. Polaroid 20x24 Polapan photograph

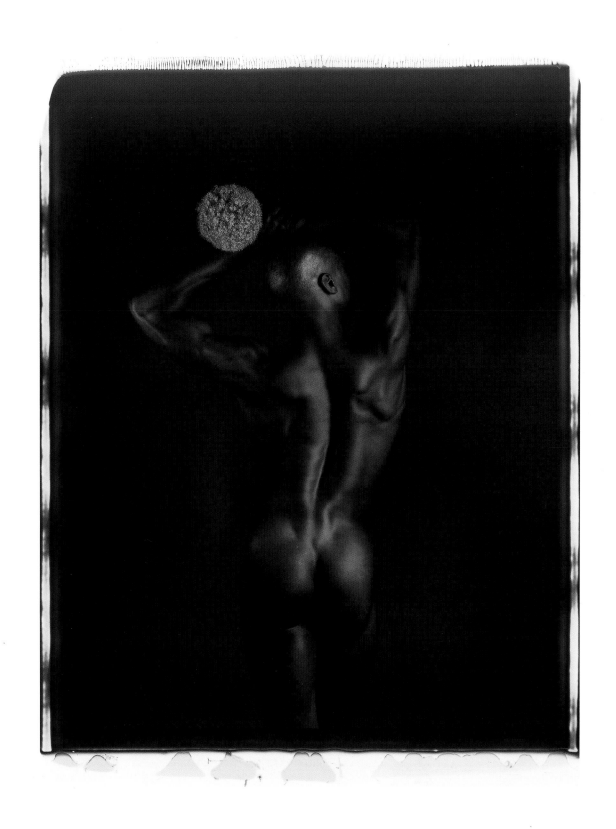

Robert Mapplethorpe. USA. *Ken Moody*. 1984. Polaroid 20x24 Polacolor photograph

60

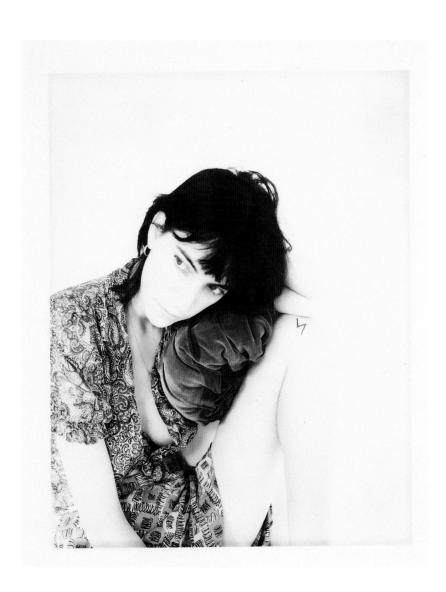
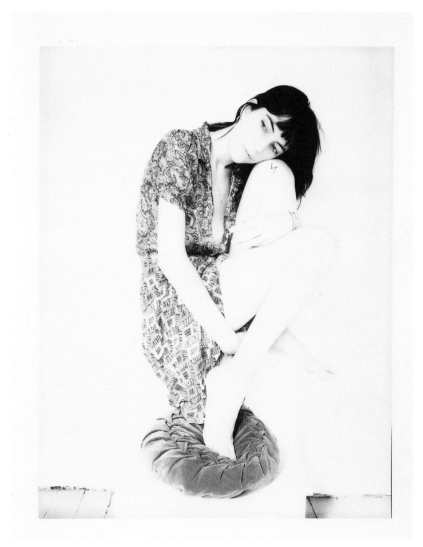

Robert Mapplethorpe. USA. *Patti Smith.*
c.1979. Polaroid Polacolor 4x5 film Type 58

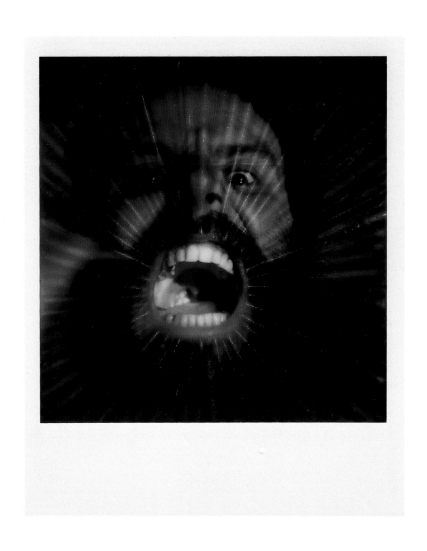

Lucas Samaras. USA. *Photo-Transformation*. 1973. Manipulated Polaroid SX-70 photograph

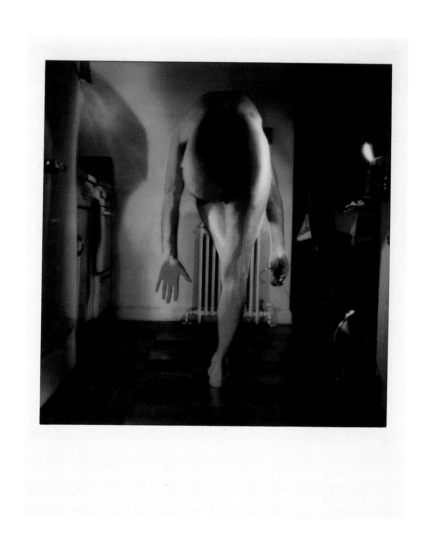

Lucas Samaras. USA. *Photo-Transformation.* 1973–76. Polaroid SX-70 photograph

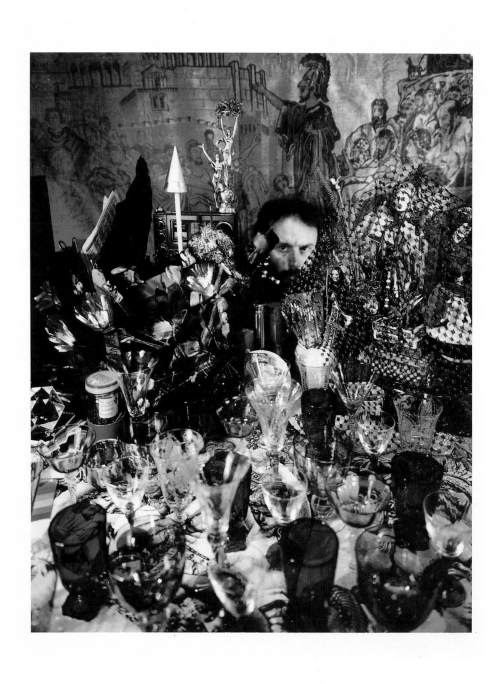

Lucas Samaras. USA. *Still Life & Figure*. 1978. Polaroid Polacolor 8x10 film Type 808

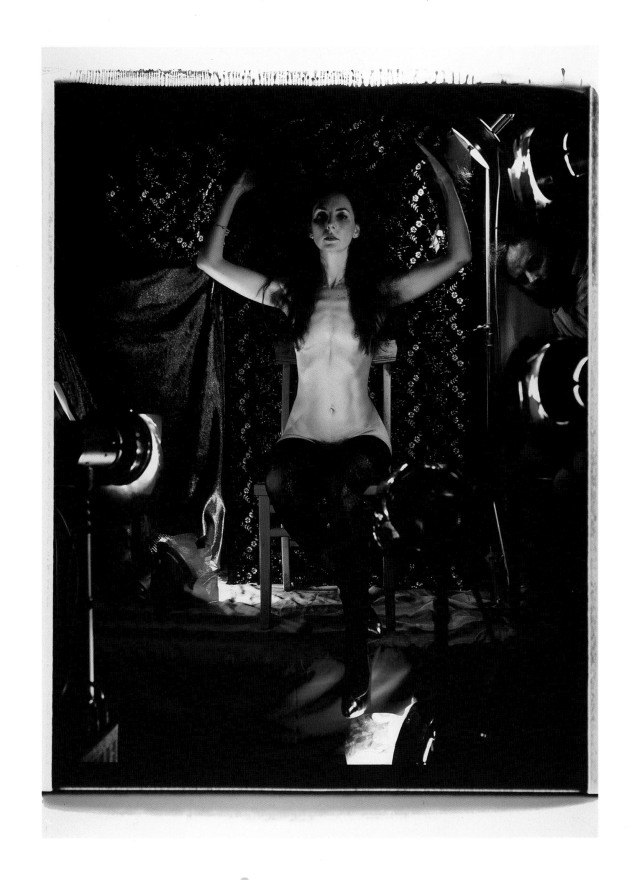

Lucas Samaras. USA. *Sitting*. 1980. Polaroid 20x24 Polacolor photograph

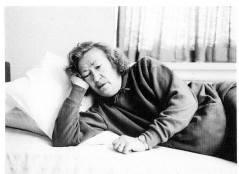

I Look young—I Feel
Great! I dont think of
Myself as old. I'm Lucky!
BUT—

The condition of elderly people is sad.
There are times I Talk To and see people here—
and Then cry.
 They ache so bad! Old people need help!
They get The Feeling That They are a burden—
A stone around The Neck.
 THEY ARE SO LONELY
 If only people would visit here—but
Young people Turn Their backs—They're Afraid!

 I'd like to hiT Them with my cane.

THEY'LL LEARN—EVERYBODY GETS OLD
 Mary E. H.
 Neville Manor

Jim Goldberg. USA. *Mary E.H.* (from the series *Nursing Home*). 1985.
Gelatin silver print from Polaroid Positive/Negative film Type 665

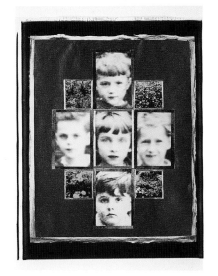

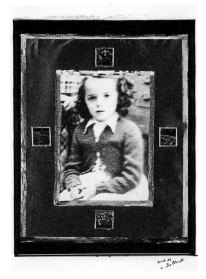

Christian Boltanski. France.
Les Monuments I–III. 1985.
Polaroid 20x24 Polacolor photographs

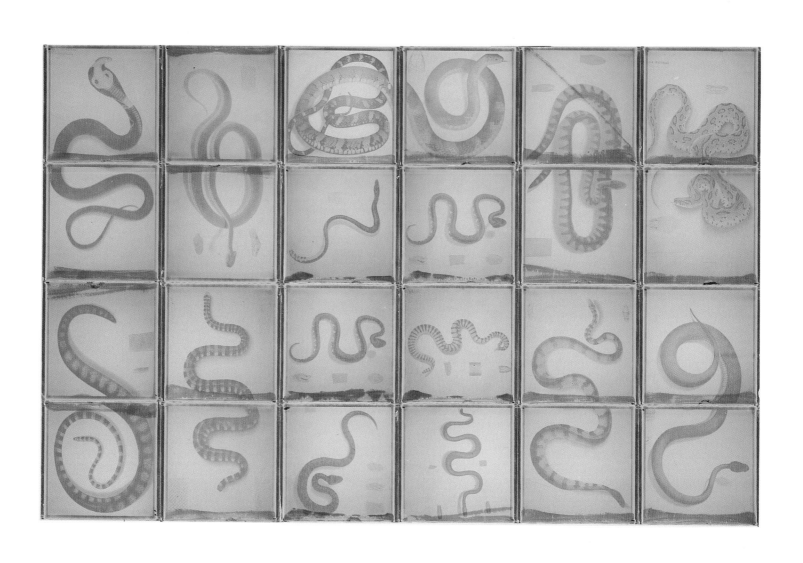

Rick Hock. USA. *Snake Script*. 1986. Manipulated Polaroid SX-70 photographs

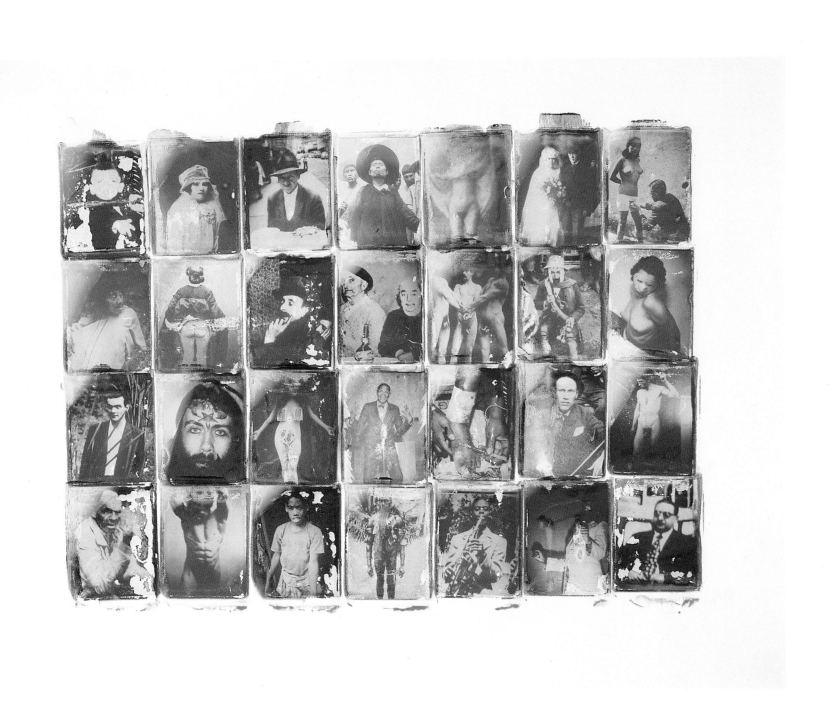

Rick Hock. USA. *Green Codex III*. 1987. Polaroid Polacolor Type 669 transfers on paper

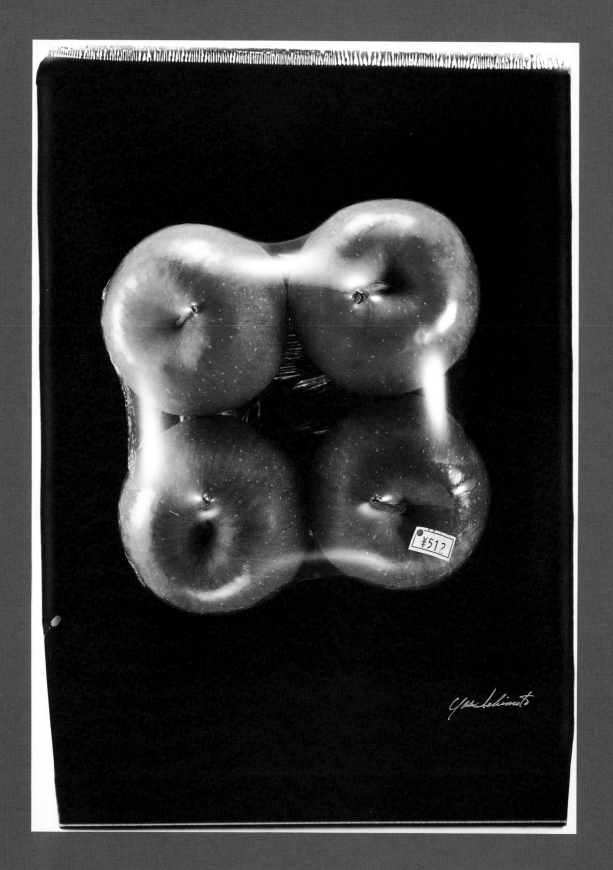

Yasuhiro Ishimoto. *Japan. Wrapped Foods. 1984. Polaroid 20x24 Polacolor photograph*

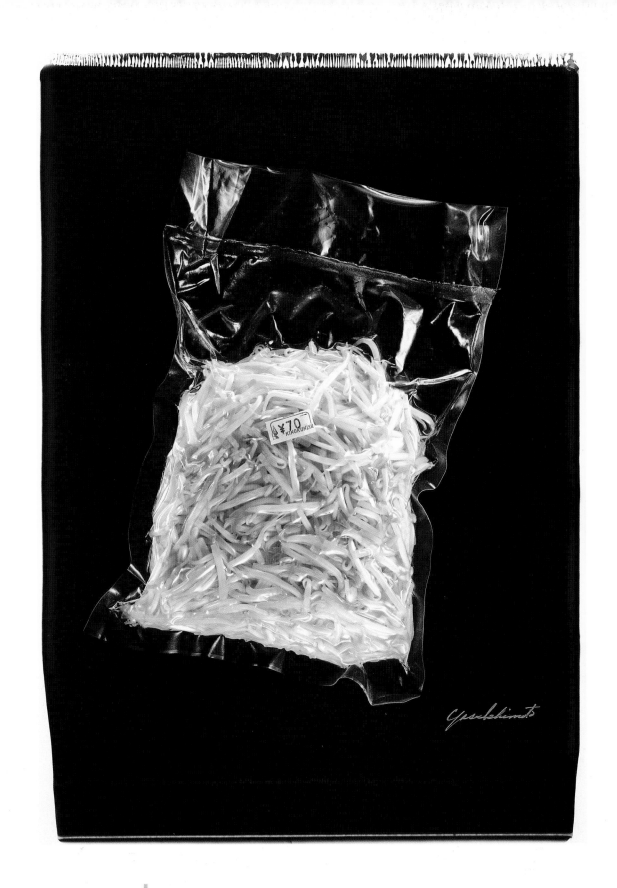

Yasuhiro Ishimoto. Japan. *Wrapped Foods.* 1984. Polaroid 20x24 Polacolor photograph

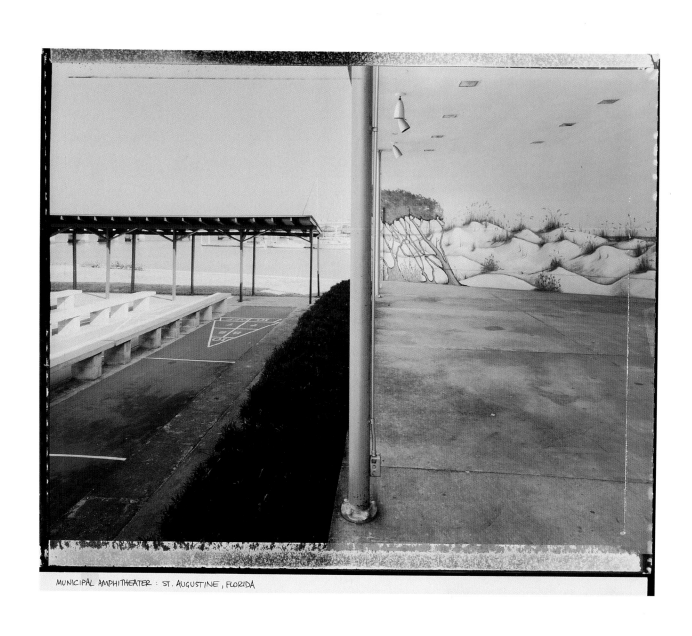

MUNICIPAL AMPHITHEATER : ST. AUGUSTINE, FLORIDA

Jim Stone. USA. *Municipal Amphitheater: St. Augustine, Florida.* 1984.
Gelatin silver print from Polaroid Positive/Negative 4x5 film Type 55

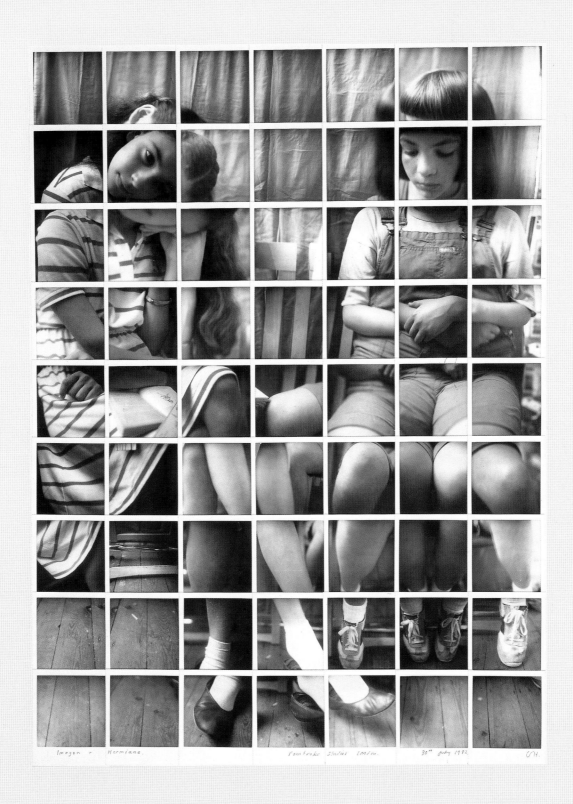

David Hockney. USA. *Imogen & Hermiane, Pembroke Studios, London, 30th July, 1982.* 1982. Polaroid SX-70 composite

F r e d e r i c **K a r i k e s e**. Belgium. *Untitled*. 1985. Polaroid SX-70 photograph

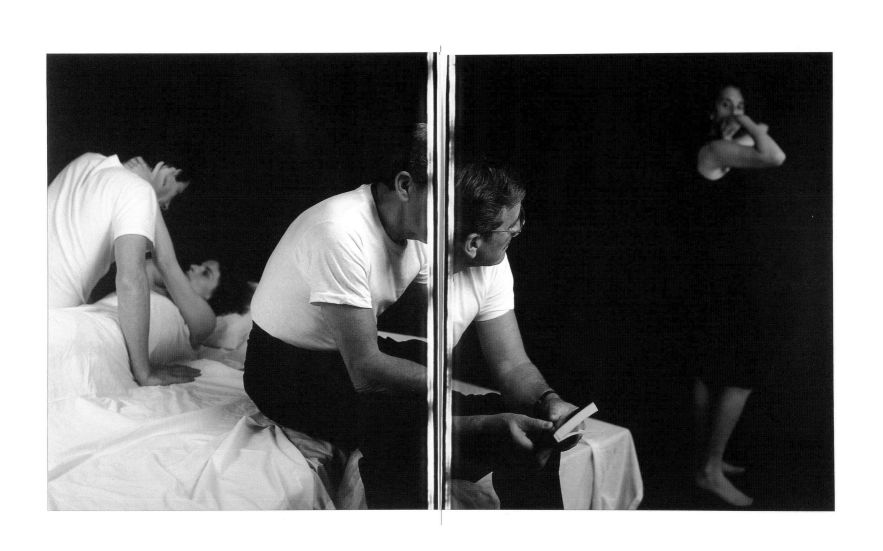

Eileen Cowin. USA. *Untitled.* 1985. Polaroid 20x24 Polacolor photographs

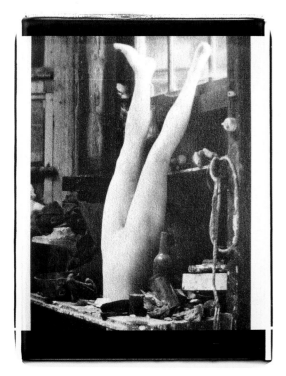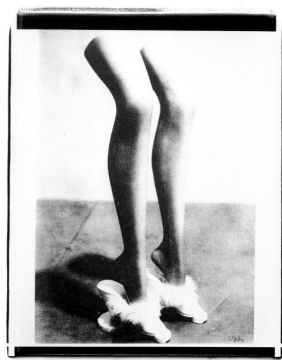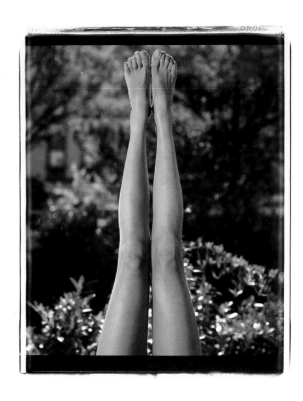

Davide Mosconi, Italy. *Untitled.* 1987. Polaroid 20x24 Polacolor photographs

Jean-Luc **K**oenig. Luxembourg. *Sommeil Eternel.* 1988.
Toned gelatin silver print from Polaroid Positive/Negative film Type 665

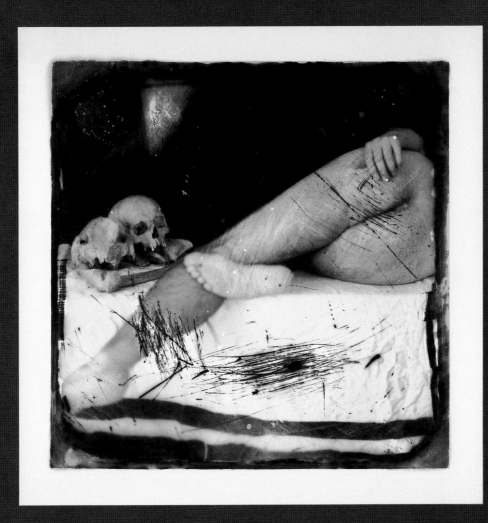

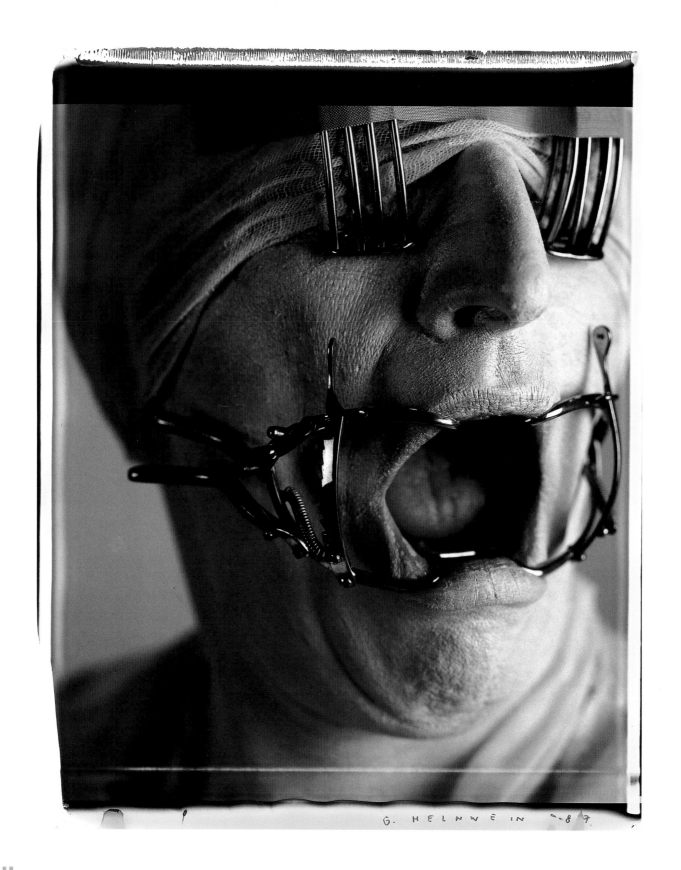

G. HELNWEIN '87

Gottfried Helnwein. Germany. *Self-Portrait.* 1987. Polaroid 20x24 Polacolor photograph

Béatrice Helg. Switzerland. *Visages de Silence*. 1981. Polaroid Time-Zero photograph

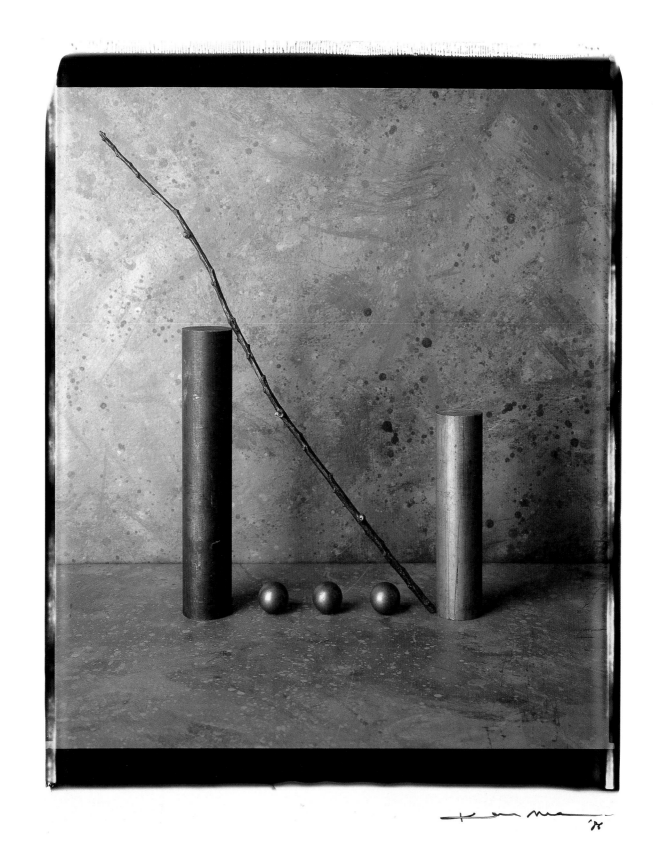

Ken Matsubara. Japan. *Untitled*. 1987. Polaroid 20x24 Polacolor photograph

82

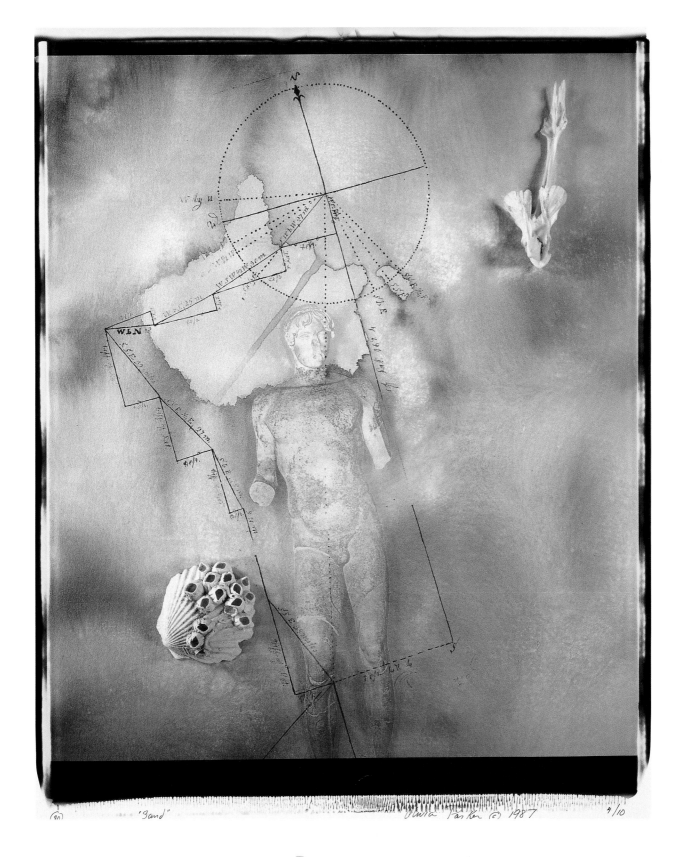

"Sand" Olivia Parker (c) 1987 4/10

Olivia Parker. USA. *Sand.* 1987. Polaroid 20x24 Polacolor photograph

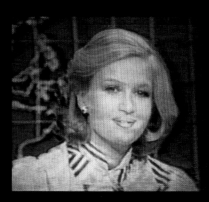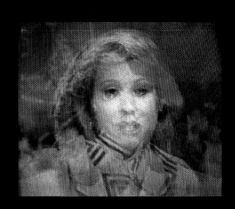

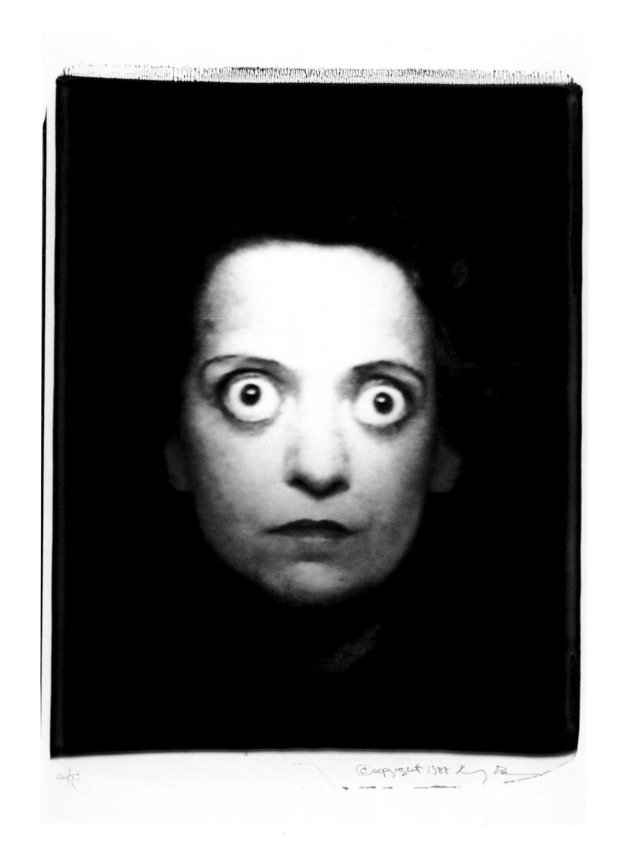

Nancy Burson. USA. *Untitled.* 1989. Computer-generated Polaroid 20x24 Polacolor photograph

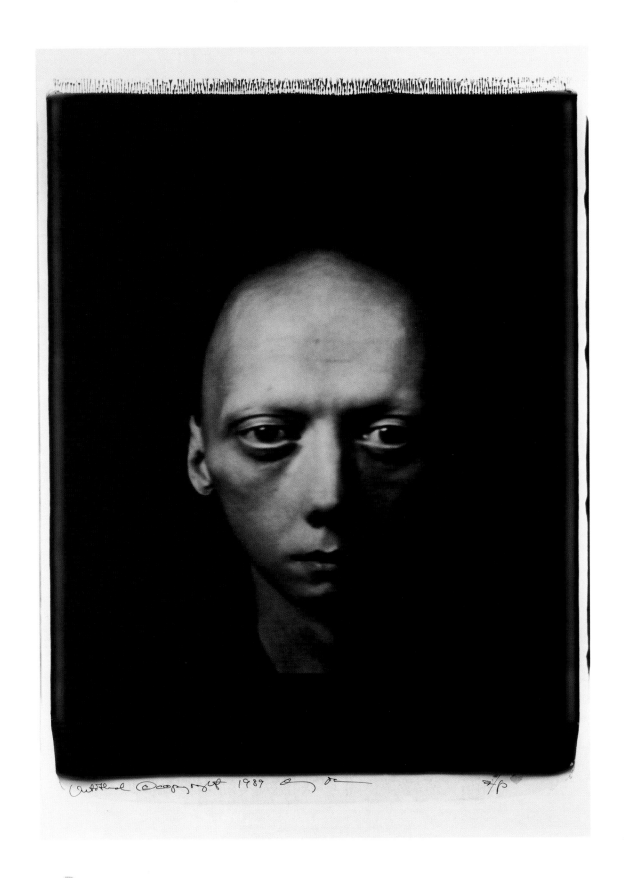

Nancy Burson. USA. *Untitled.* 1988. Computer-generated Polaroid 20x24 Polacolor photograph

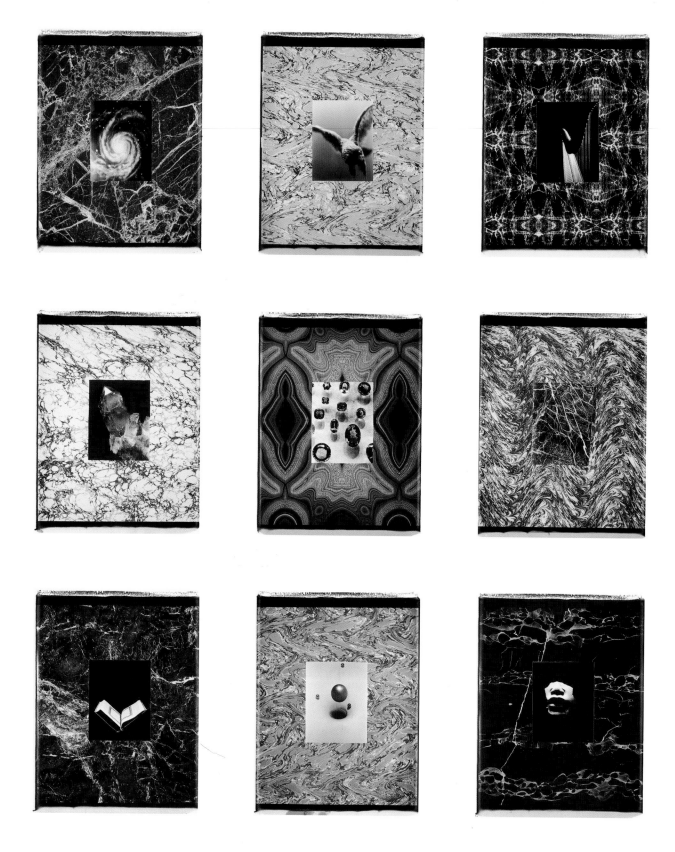

Judy Dater. USA. *Cycles*. 1989. Polaroid 20x24 Polacolor photographs

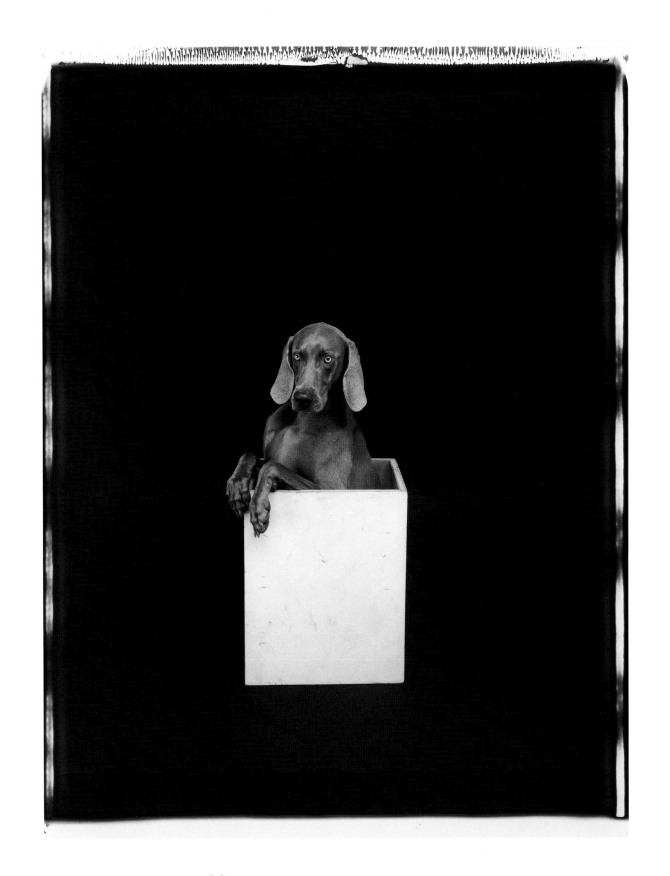

William Wegman. USA. *Fay in a Box.* 1987. Polaroid 20x24 Polacolor photograph

Robert Rauschenberg. USA. From the *Bleacher Series: Japanese Sky I.* 1988.
Bleached Polaroid 20x24 Polapan photographs

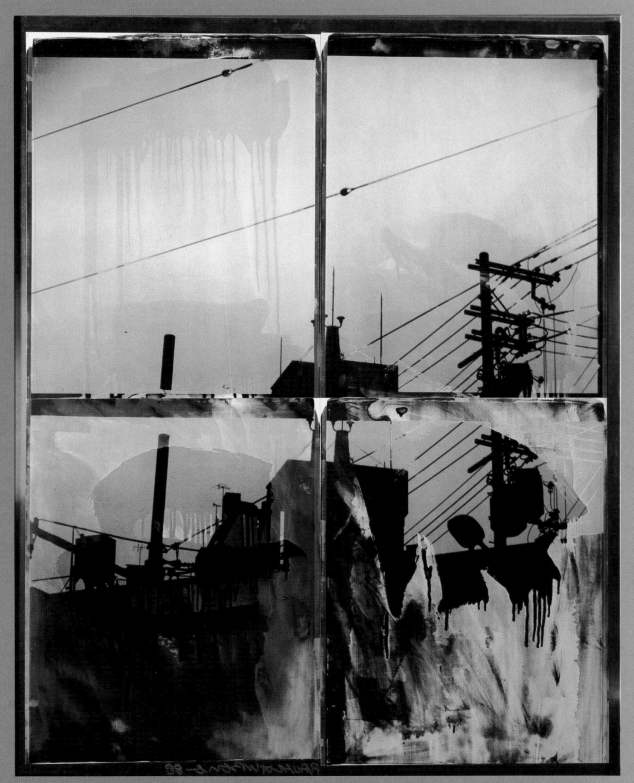

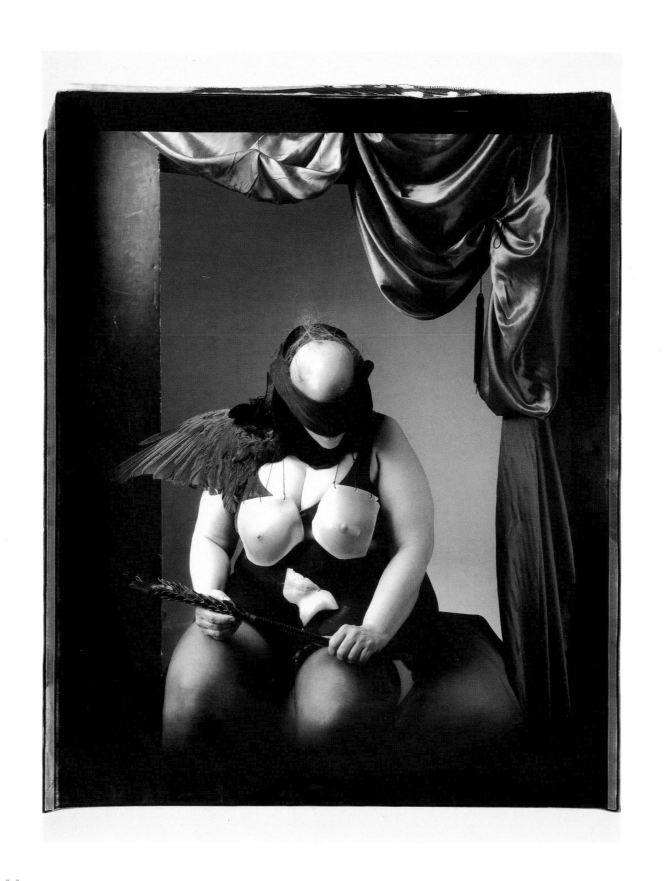

Joel-Peter Witkin. USA. *Dominatrice*. 1988. Polaroid 20x24 Polapan photograph

92

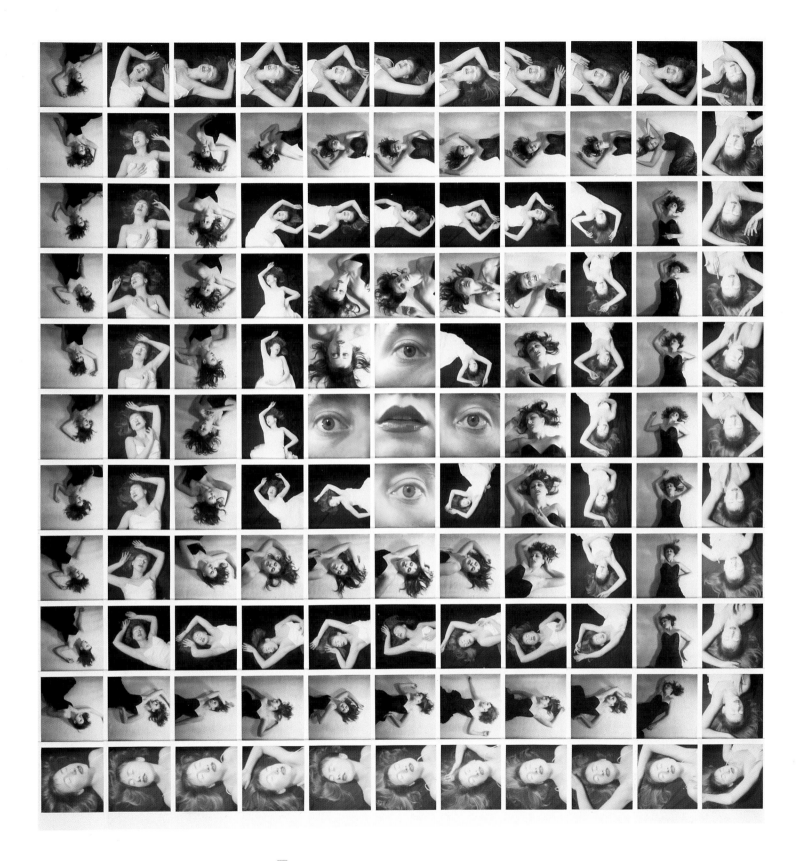

Silvia Taccani. USA. *Composite #115*. 1988. Polaroid Type 600 High Speed film

John Divola. USA. *Untitled.* 1989. Polaroid 20x24 Polapan photographs

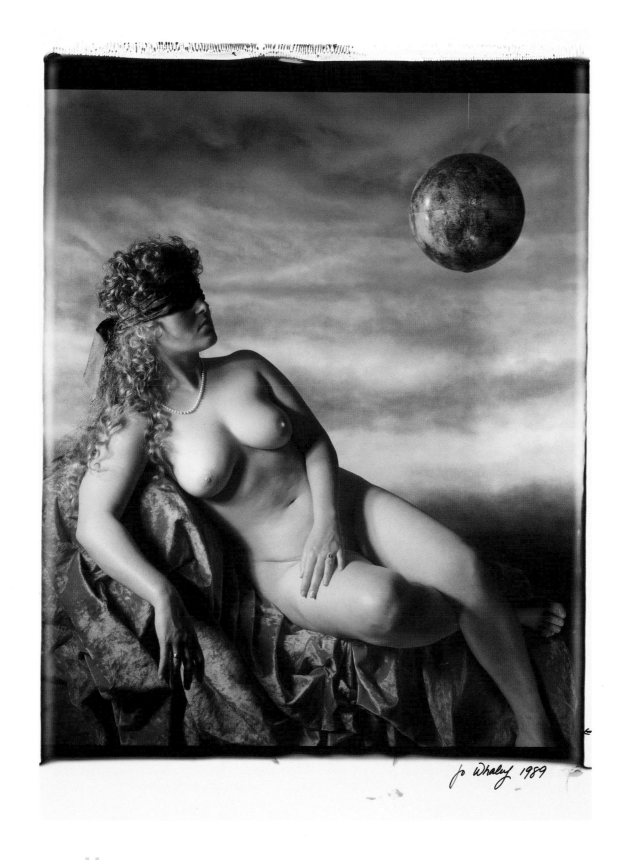

Jo Whaley. USA. *The Observer of Decadence*. 1989. Polaroid 20x24 Polacolor photograph

Werner Hannappel. Germany. *France.* 1989.
Gelatin silver print from Polaroid Positive/Negative 4x5 film Type 55

Werner Hannappel. Germany. *France.* 1989. Gelatin silver print
from Polaroid Positive/Negative 4x5 film Type 55

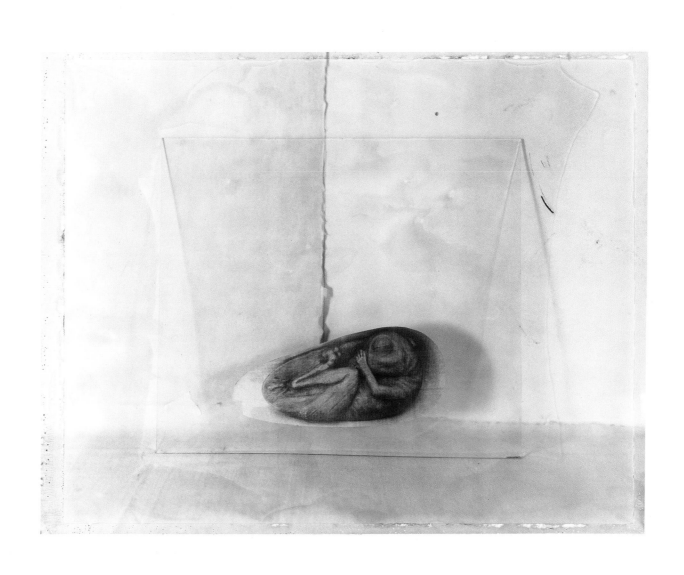

Debra Goldman. USA. *Untitled.* 1988. Sepia-toned gelatin silver print from Polaroid Positive/Negative 4x5 film Type 55

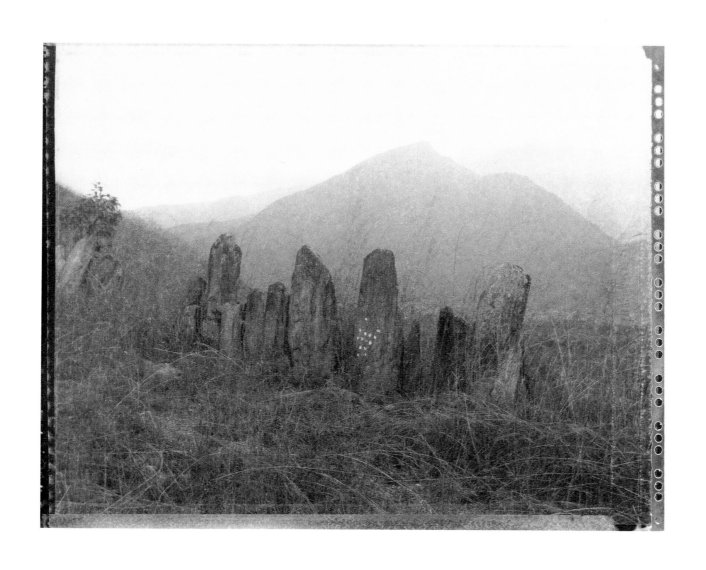

Sandro Oramas. Venezuela. *Pre-Columbian Standing Rocks and Petrogyphs, Vijirima, Venezuela.* 1989. Platinum/Palladium print from Polaroid Positive/Negative 4x5 film Type 55

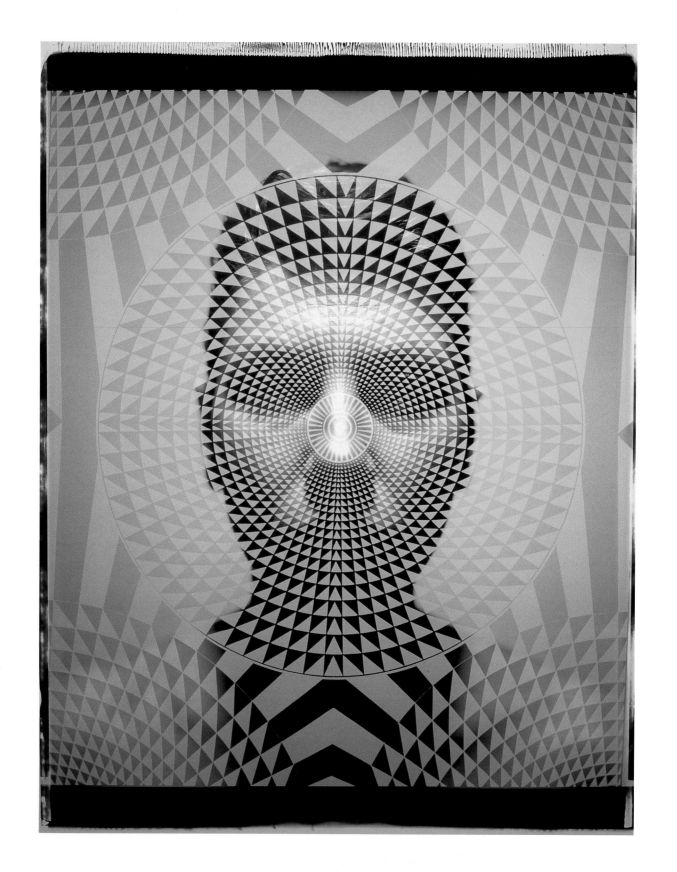

Ellen Carey. USA. *Untitled*. 1986. Polaroid 20x24 Polacolor photograph

Photographs

The 1990s

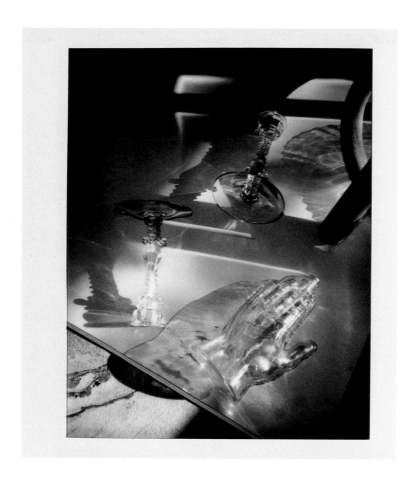 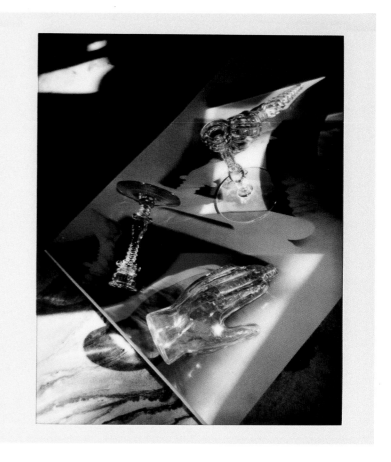

Anita Douthat. USA. *La Mano Sangrante*. 1992. Polaroid Spectra (Image) System film composite

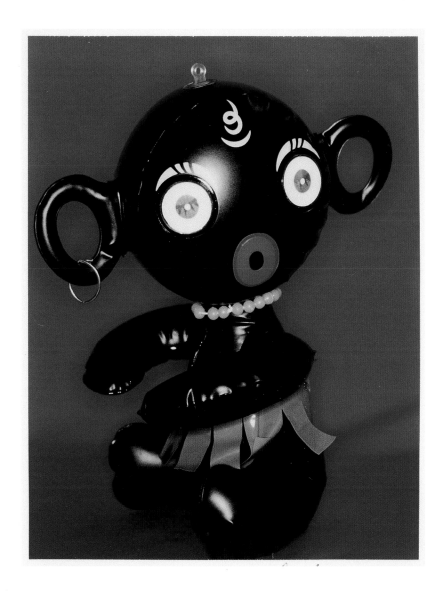
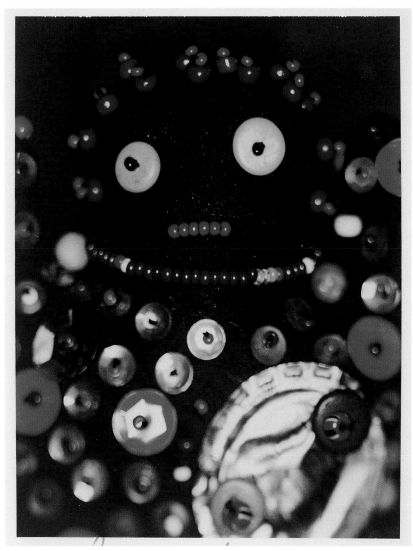

Jeff Hoone and Carrie Mae Weems. USA. *Untitled.* 1993. Polaroid PC PRO 100 film

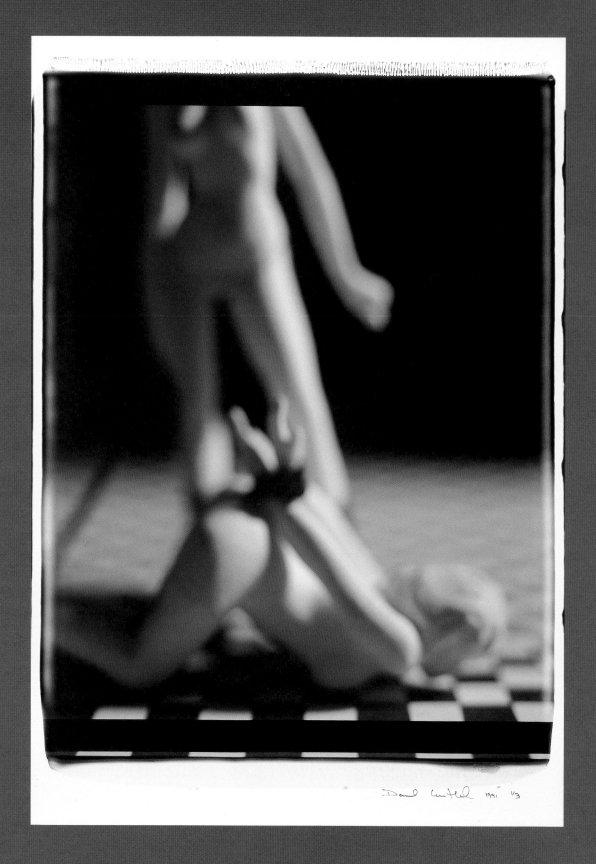

David Levinthal. USA. *Untitled* from the series *Desires*. 1991. Polaroid 20x24 Polacolor photograph

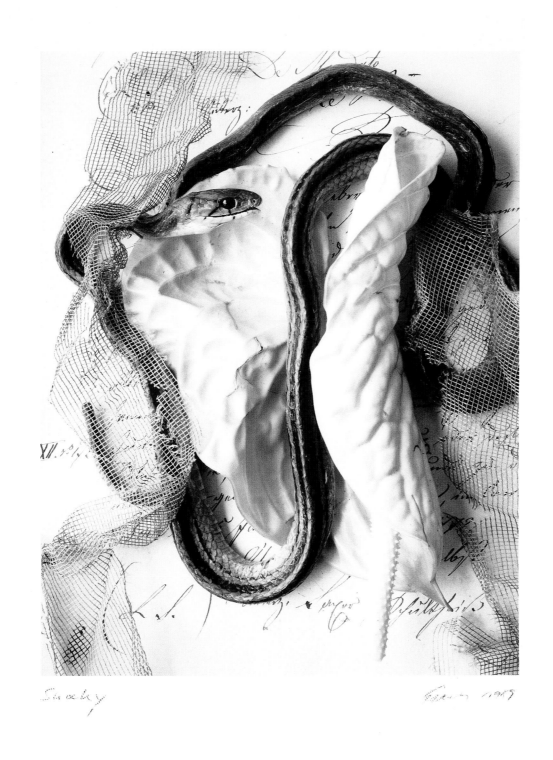

Eberhard Grames. *Germany. Snaky.* 1990. Polaroid Polapan 8x10 film Type 803

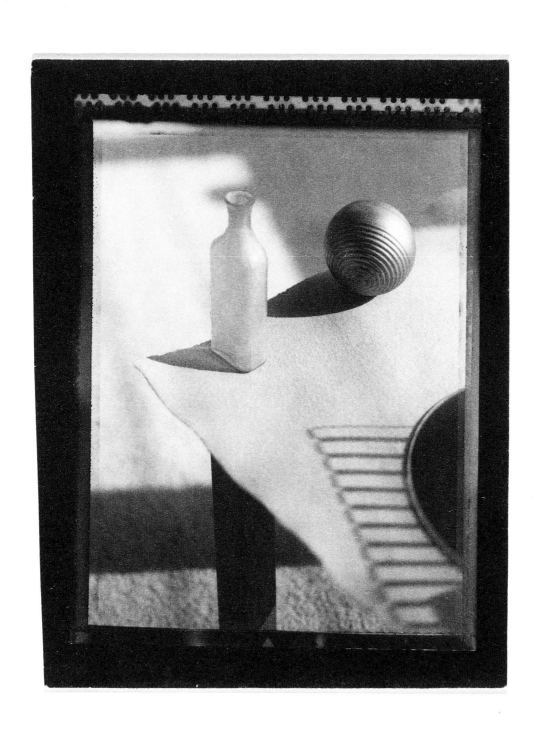

Rei Taka. USA. *Still Life #61*. 1992. Platinum/Palladium print from
Polaroid Positive/Negative film Type 55

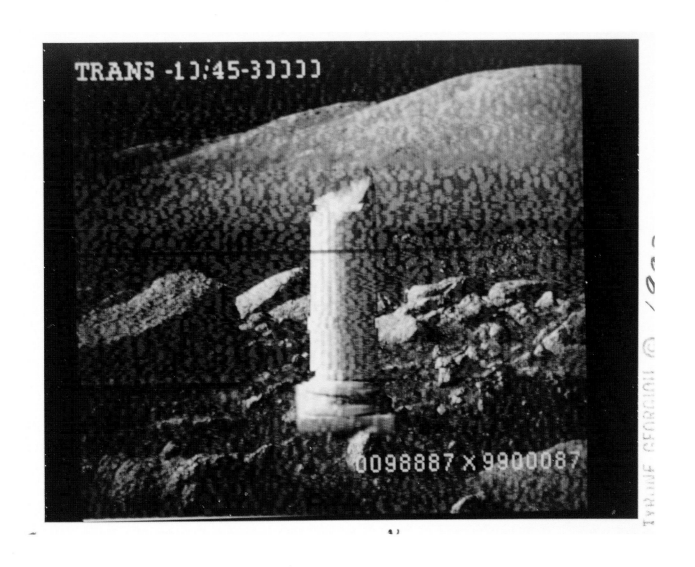

Tyrone Georgiou. USA. *Garbled Transmission #1*
(from the *Discovery Series*). 1993. Polaroid PC PRO 100 4x5 film

Fazal Sheikh. USA. *Gabbra Matriarch (seated at center) with Gabbra Women & Children, Ethiopian Refugee Camp.* 1993. Gelatin silver print from Polaroid Positive/Negative film Type 665

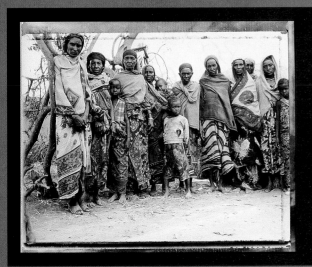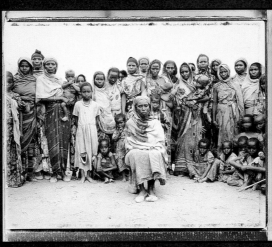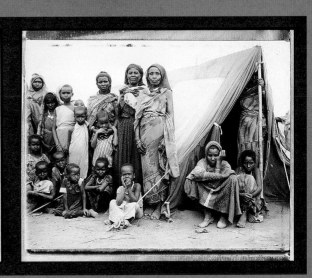

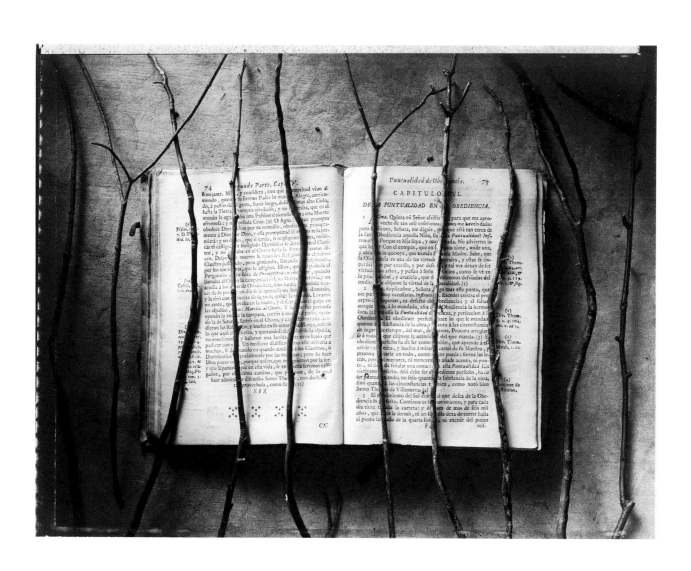

Sean Kernan. USA. *Books II* (from the series *The Secret Books*). 1992.
Toned gelatin silver print from Polaroid Positive/Negative 4x5 film Type 55

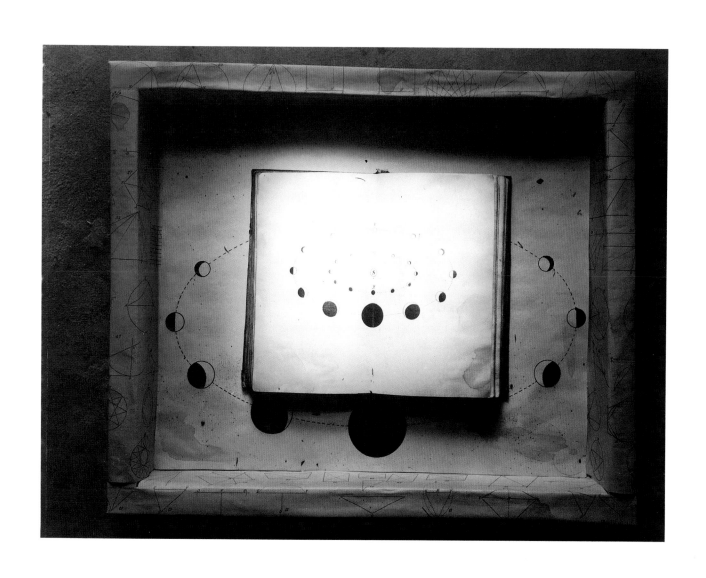

Sean Kernan. USA. *Books XII* (from the series *The Secret Books*). 1993.
Toned gelatin silver print from Polaroid Positive/Negative 4x5 film Type 55

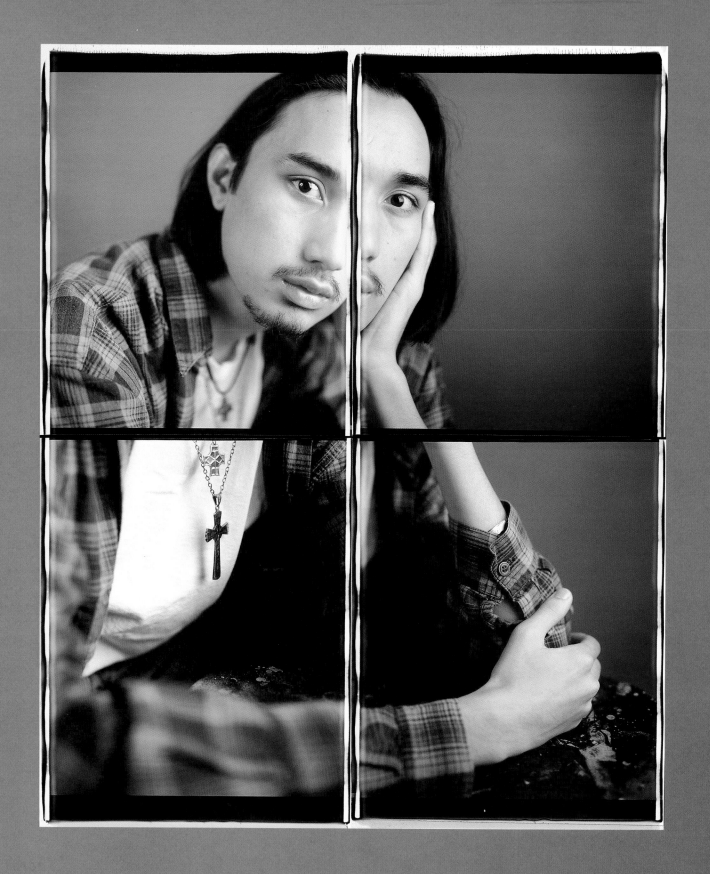

Dawoud Bey. USA. *Josef.* 1993. Polaroid 20x24 Polacolor photographs

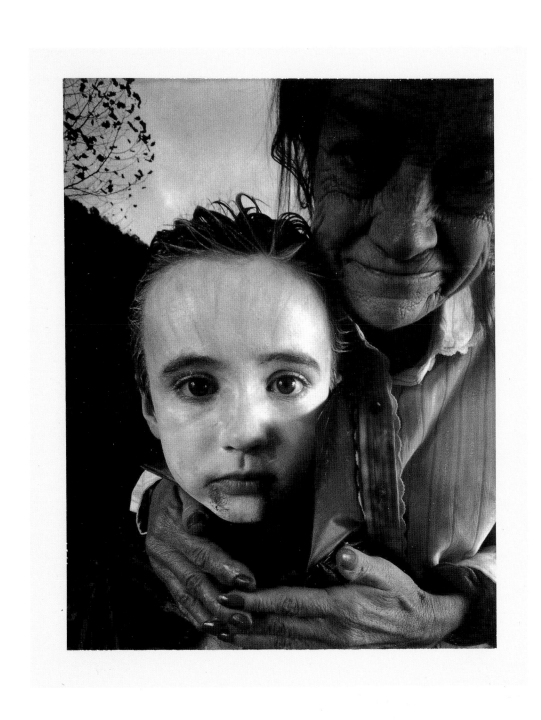

Shelby Lee Adams. USA. *Appalachian Dracula with Granny.*
1993. Polaroid Polapan 4x5 film Type 52

Polaroid and the Artist

For the past fifty years, photographers have worked with Polaroid cameras and film. Here they comment on why:

Instant Process

The two photographs by Ansel Adams included here, *Yosemite* (1955) and *Cascades* (1956)—and the memorandum with photos from 1953—represent only a fraction of the artist's Polaroid prints. Indeed, Adams believed that many of his best photographs from the 1950s onward were made on Polaroid film. In *Examples: The Making of 40 Photographs,* he wrote that the "immediate feedback" of the Polaroid process was valuable because it provided "additional opportunity for refining composition and seeing small confusing elements of the subject that might have been overlooked in the original visualization." Adams also commented in his autobiography on the beauty of Polaroid photography: "One look at the tonal quality of the print I achieved should convince the uninitiated of the truly superior quality of Polaroid film."

Adams's estimation of the Polaroid instant process is echoed by many photographers. Rosamond Wolff Purcell, who began photographing with Polaroid film in the 1970s, states, "This medium encourages play and active participation, and demands that you figure it out as you go along. Because you're generally working from print to print, you can't pretend. You know right away whether it's successful or not." Gottfried Helnwein elaborates, "In my work I am always impatient and hate anything that slows down the speed of creation. Polaroid film shows me the results of my work immediately and shows me pitilessly where I stand."

Photographers also gain an almost visceral pleasure from the instant process. Ken Matsubara describes the "excitement and feelings of wonder" that he experiences while waiting for an image to appear, and Nancy Burson calls it "the biggest instant gratification process."

William Christenberry has found that the instant photographic process creates a "freeing of intuition," allowing him to take risks and experiment in ways that he would not if he were unable to view the results right away. He likens this spontaneous, immediate nature of the medium to drawing. The analogy is repeated by Sean Kernan, who says, "Using Polaroid film has slowed me down"—this may seem the opposite of its intent, but Kernan explains that instant film "introduces aspects of sketching, erasing, manifesting, and then refining. It let's one stare, be silent, make an image, then *revise.*"

For portrait photographers, Polaroid cameras and film enable a dialogue between the artist and the sitter. In other types of photography, the sitter has no opportunity to see what the photographer is seeing; with instant photography, the sitter sees every print. "Invariably," Chuck Close states, "the sitter sees the first print and says, 'You're not going to use *that* one, are you?'" Shelby Lee Adams, who photographs families in the Appalachian region of his native Kentucky, enjoys giving 4x5-inch Polaroid prints to his subjects immediately, especially the children, "who can barely wait a minute." This meant a great deal to the grandmother in the portrait by Adams included here, *Appalachian Dracula with Granny* (1993), who was able to see a photograph of herself and her grandson instantly; the next time Adams returned to the home, he was told that the grandmother had died.

The creation of a self-portrait is also aided by the immediacy of the Polaroid process, which, according to Silvia Taccani, allows her "to be on both sides of the camera almost simultaneously. It provides a virtual freeze-frame mirror that gives me the flexibility to refine and elaborate ideas on the spot while maintaining spontaneity."

Manipulated Images

Introduced in 1972, the Polaroid SX-70 camera was the first fully automated, pocket-sized camera, producing color prints without a peel-apart sheet. Inventive artists soon found ways to manipulate the film and create their own effects. One way this is achieved is by the handling of the photographic film itself. The color balance of SX-70 film is sensitive to temperature and the color of the light source utilized. Lucas Samaras—here represented by four works, two of which are SX-70 photographs—achieves his brilliant colors by warming the film before exposure, placing it under a lamp; colored light also changes the photograph because the film is affected by the color temperature.

Once the print has emerged from the camera, it can be further altered with the use of a stylus, pencil, or some other object, by pressing down on the photograph. The emulsion layers, held between the top layer of Mylar and the backing, are broken down and mixed, creating new contours and textures; this artistic strategy does not work on the peel-apart Polaroid films.

To create *Snake Script* (1986), a composite of twenty-four SX-70 photographs, Rick Hock completely removed the Mylar covering and foil wrapping during development. The image thus produced has a more textured surface, like paint, and is softer and more monochromatic; the "faults and defects" created make the image more physical and more like an object. Hock explains, "The primary reason for using this material is that it can be manipulated to create a physical form that is equivalent to the content I am interested in. The way I use it creates unpredictable effects that can lead to results that are more than I could imagine."

The SX-70 photograph is not the only Polaroid print that can be manipulated. Robert Frank has often photographed with Polaroid cameras and Positive/Negative film, which creates both an instant print and a reusable negative. Frank

twists the negative as he pulls the film packet through the camera's rollers, changing the image even before it has developed. He then scratches words onto the Polaroid negative, recording his thoughts over the image, branding them *into* the image. "*Pour la fille,*" the inscription on this 1980 work, is a dedication to his neighbor's newborn daughter; the words overlay a field of flowers blurred by wind and the photographer's slow shutter speed.

20x24 Camera

In 1978 Polaroid introduced the 20x24 camera, which produces 20x24-inch instant color and black-and-white photographs. The camera was initially developed two years earlier to demonstrate the quality of large-format Polacolor film to company shareholders. At the annual Polaroid meeting held at the Waldorf Hotel, a portrait was made of Andy Warhol using the camera prototype, which weighed 600 pounds and sat on a barber chair support that served as its tripod. Six of these cameras now exist—trimmed down to 235 pounds and standing five feet high—in New York, Boston, Cambridge, San Francisco, and Prague.

When the camera was first introduced, Polaroid invited numerous artists to experiment with it; the photographs in this book mark only a fraction of the number thus garnered for the Polaroid Collection. Chuck Close was one of the first artists to use the 20x24 camera. He originally thought of himself as a painter only, not a photographer; he took photographs of his subject only to use as a model from which to paint. However, once he began using the Polaroid camera—and thus could instantly see the image and make adjustments—he took fewer photographs. "You can't just have someone come and sit for you and only take one photograph," he explains, especially when the sitter comes from far away. Therefore he started taking photographs that he did not intend to paint from, "and once you do that," Close says, "you're a photographer."

Self-Portrait (1979) is one of a number of photograph collages that Close has made. As Close states, "These works mimic the incremental methodology by which I build my paintings," in which a face is constructed of many small squares or circles of color. Dawoud Bey is another artist who uses multiple 20x24 images; *Josef* (1994) is one in a series of his larger-than-life-size portraits of high school and college students, which produce a "heightened level of physical description."

Close also emphasizes the importance of the Polaroid technicians who work with the 20x24 camera, helping the photographer to realize the perfect image. Burson agrees that this collaboration is "one of the best reasons to use the 20x24 camera." Burson uses the 20x24 to capture digital images she has created on a computer, "portraits" that are created by mixing different faces to create a single one.

Photographers state that a primary reason for using the 20x24 camera is, of course, its large format. The size of the image itself is 20x24-inches—the total print, including borders, measures 22x30-inches; all photographs have a verti-

cal orientation. According to Christenberry, "The large scale helps to disguise the size of the object photographed." His 1984 photograph *KKK* is not a portrait of a Klansman, it is actually a doll; the hood is only 4 ½ inches tall. The photograph is part of a series called *The Klan Tableau*, which is comprised of approximately 500 sculptural objects, drawings, and photographs. The size and power of Christenberry's image are "not something that one would expect from a doll." This effect is similarly found in the work of David Levinthal, who photographs dolls as well. In his untitled 1991 20x24 photograph, from the series *Desires*, he combines this "confusion of scale" with a soft focus to lend a sense of reality to the inanimate objects.

The size of a 20x24 photograph may be its most striking characteristic, but the quality of the image produced is also singular. The camera creates contact prints, and thus the photograph does not lose grays and color in enlargement. Polaroid black-and-white film also has the highest silver content of any black-and-white film. Christenberry points out that *KKK* makes full use of the high contrast of the film, which emphasizes the image's "theatrical lighting." He underlines that "the drama and intensity come through, along with the fine detailing—the stitching, the shine of the satin." Indeed, Helnwein believes that the film quality is the most significant aspect of Polaroid film: "Much more important than the speed is the material, or texture, of the picture. The absolute tenderness of passages, the fine nuances of tone, and the integrity of color, especially with human skin, I have never found in any other medium."

Among the most vivid color photographs included in this selection are Barbara Kasten's abstract images. In *Construct XXI* (1983), Kasten produces geometric shapes by the projection of colored lights onto architectural forms and mirrors that she built in her studio. Her 1996 photographs of Mexican funerary temples, *Temple II* and *Temple IV*, show her continued focus on, in Kasten's words, "the manipulation of light, color, and scale." Kasten says that "the beautifully rich, velvety Polaroid surface makes the work more of an object than a paper transmitting a photographic illusion."

The vibrant colors in Ellen Carey's multiple-exposure photograph from 1986 are achieved by what she calls the "soft-edged brilliance" of Polaroid film, and she feels that the Polaroid process is integral to her work. She explains, "One question frequently asked about my work is 'How was this picture made?' More recently, this has been joined by the question, 'What is this a picture of?'" Carey's goal is the creation of art that "challenges the historically and culturally prescribed expectation that photographs will record, describe, document, or depict 'reality.'"

Davide Mosconi first used the 20x24 camera at the invitation of Polaroid, when the camera was brought to Italy. He describes the 20x24 print as "a beautiful thing, as beautiful as a daguerrotype—it is physical, tactile, and visual." His work with the camera affected him greatly. "I was going through a difficult period in my life, a turning point," he says. "Working with the Polaroid camera brought me back to the joy of photography. It was one of the most beautiful experiences I've had in my life."

Polaroid Milestones

Edwin H. Land

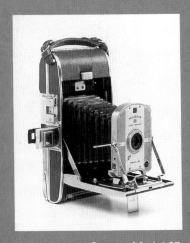

Polaroid Land Camera Model 95

1937 Polaroid Corporation is formed

1944 Land begins work on instant photography

1947 Instant photography is born: Land demonstrates one-step sepia film to the Optical Society of America, February 21

1948 Polaroid Land Camera Model 95 and sepia-tone film go on sale, November 26

1950 Black-and-white Polaroid film, Type 41, is introduced

1951 Polaroid 3-D glasses and polarizing filters on projectors make possible the first color stereoscopic 3-D movie, *Bwana Devil*
 Polaroid Medical Imaging Type 1001 Film: produces 10 x12" X-ray print in just 60 seconds

1961 Type 55 Positive/Negative Land Film: the first Polaroid film that produces both a positive and a negative, the latter which can be reused to create another 4 x 5" positive print or enlargement (in 1977 Type 665, a 3¼ x 4¼" Positive/Negative film, is introduced)

1963 Instant color film is invented: instant color prints from roll film, Type 48 and 38 Polacolor film
 Polaroid Land Camera Model 100: first camera ever made that uses transistorized electronic shutter for automatic exposure control; uses new pack film, Type 107 black-and-white and Type 108 Polacolor film

1965 Swinger camera and Type 20C black-and-white film: low-cost camera and film

1966 ID-2 Land Identification System: first self-contained identification system using instant photography

1972 Land demonstrates the SX-70 system at a meeting of Polaroid shareholders, April 25: the first self-timing, electronically controlled and motor-driven, folding single-lens reflex camera—a pocket-sized camera that produces full-color prints with a 3⅛ x 3⅛" image area, without a peel-apart sheet

1976 20x24 camera is introduced at the annual Polaroid shareholders meeting: produces both color and black-and-white 20x24" contact photographs in just 70 seconds—the image area measures 20x24" on an overall print size of 22x30". The full-size Fresnel viewing screen provides a brighter, clearer picture than possible with most view cameras, and facilitates focusing and framing. The system includes a built-in processing mechanism and an adjustable digital timer. Lenses, ranging from 135 mm to 600 mm, enable minute reduction as

well as 10 times magnification. Three films are used in the camera: Polacolor ER color film, Polapan black-and-white film, and Polacolor PRO film. Polacolor ER produces natural skin tones; Polapan is a high-speed, medium contrast, panchromatic black-and-white film; Polacolor PRO creates more vibrant colors.

A room-sized camera producing 40 x 80" prints is installed at the Museum of Fine Arts, Boston (it is later moved to Cambridge, MA): the camera makes replicas of paintings, frescoes, and other works of art too delicate or too large to be reproduced accurately by traditional methods. A 40 x 80" life-sized replica of Renoir's *Bal à Bougival* (1883) is unveiled at the Polaroid shareholders meeting.

1977 OneStep Land Camera: inexpensive, non-folding, fixed-focus instant camera—becomes best-selling camera (instant or conventional) in the world for the next four years

8 x 10 photographic system: produces 8 x 10" instant color prints

SX-70 Land camera

1978 Polavision: instant color motion picture system

1979 40 x 80 camera, made of scaffolding and black Mylar sheets, is built to photograph Raphael's *Transfiguration* at the Vatican

Time-Zero film: a faster-developing film, with brighter colors and whites, for the SX-70 camera

1981 Sun 600 Light Management System: camera and Type 600 High Speed Film

1983 35 mm Autoprocess System: produces color or black-and-white transparencies in less than three minutes

1986 Spectra System (known as Image System in Europe): consists of a computerized camera and an instant color film, with accessories such as a remote-control device and laser print service. It produces a rectangular print with an image area larger than 600 series film.

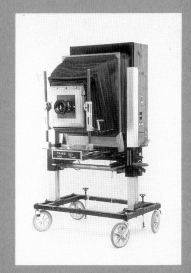

1992 Captiva camera and film system: ultra-compact, incorporating picture storage compartment

1995 Macro 5 SLR camera: 5 mm close-up system

1996 PDC-2000 digital camera is introduced

20x24 camera

1997 Polaroid PhotoMax digital camera creative kit: software tools for building websites

Digital microscope camera: for scientific, medical, and industrial micrography

Inkjet photo paper: produces color prints from inkjet printers with the look and feel of photographs

1998 Polaroid Pocket camera (first introduced in Japan, by the Japanese company Tomy, as the Xiao camera): the world's smallest instant camera

Single-use instant camera with compact film format is introduced

Index of Photographers

Numbers refer to pages on
which photographs appear